Copyright 2013 Keir McLaren
All Rights Reserved

Available from amazon.com
and other online stores

Henry Kids Picture Books

Available From Amazon.com and other online stores.

Henry Meets a Tree-Legged Dog

Henry Saves Nana's Garden

Henry Visits The World's Silliest Zoo

ABSTRACT

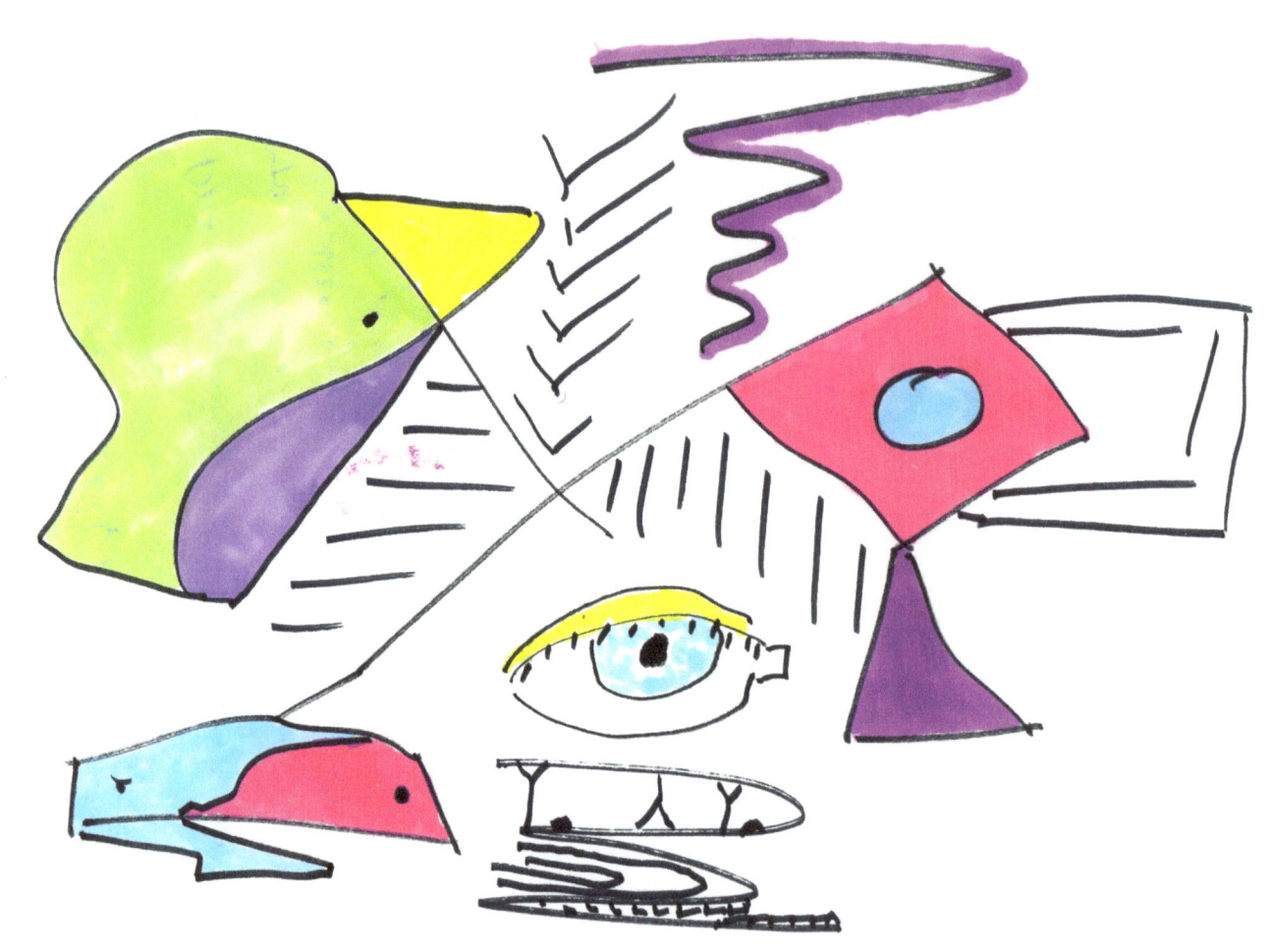

Abstract #1

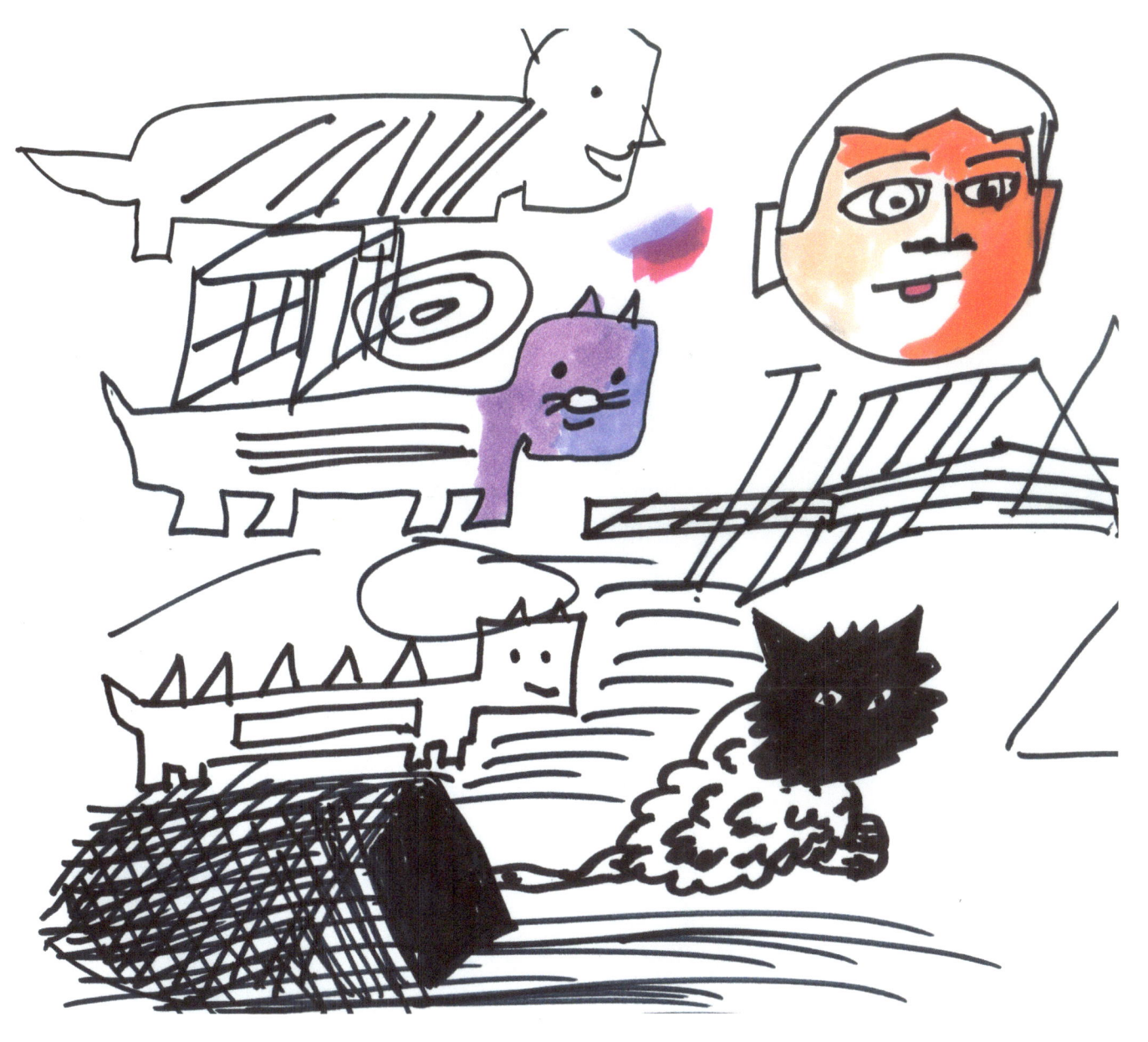

Abstract #2

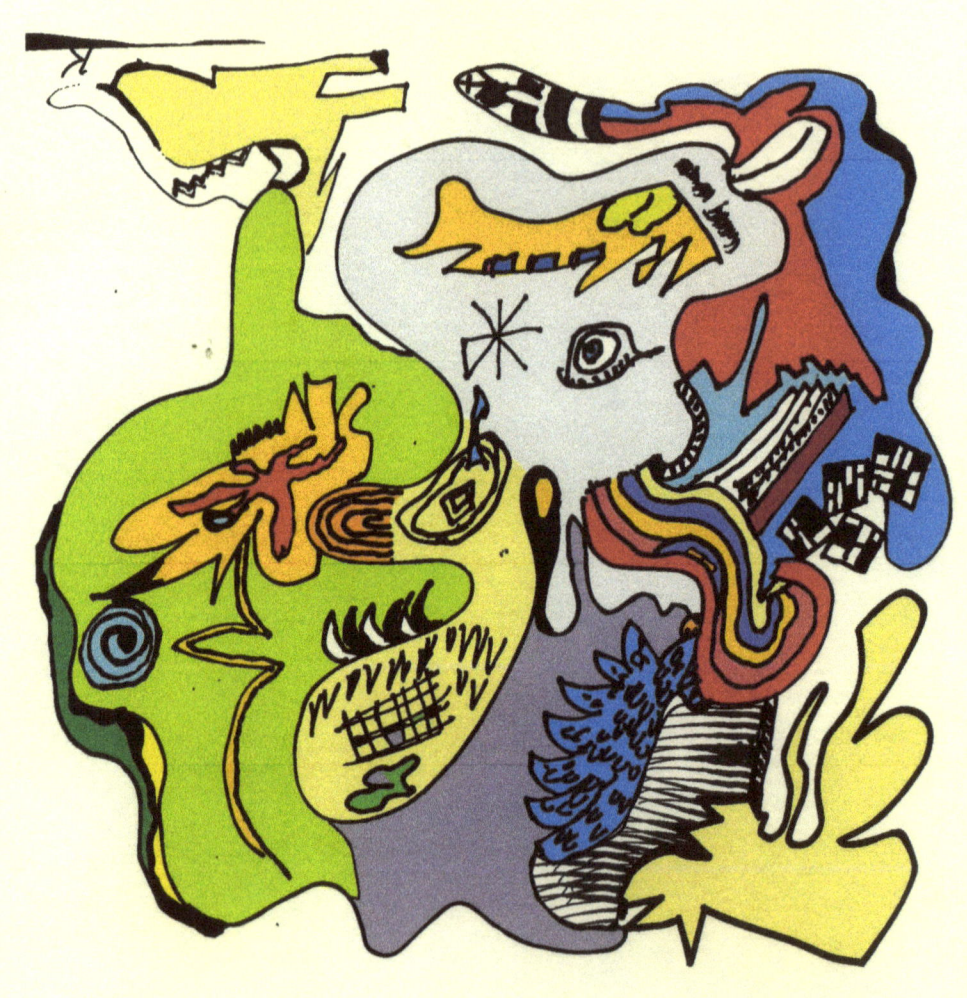

Bad Dream

Abstract: Paper 53 #1

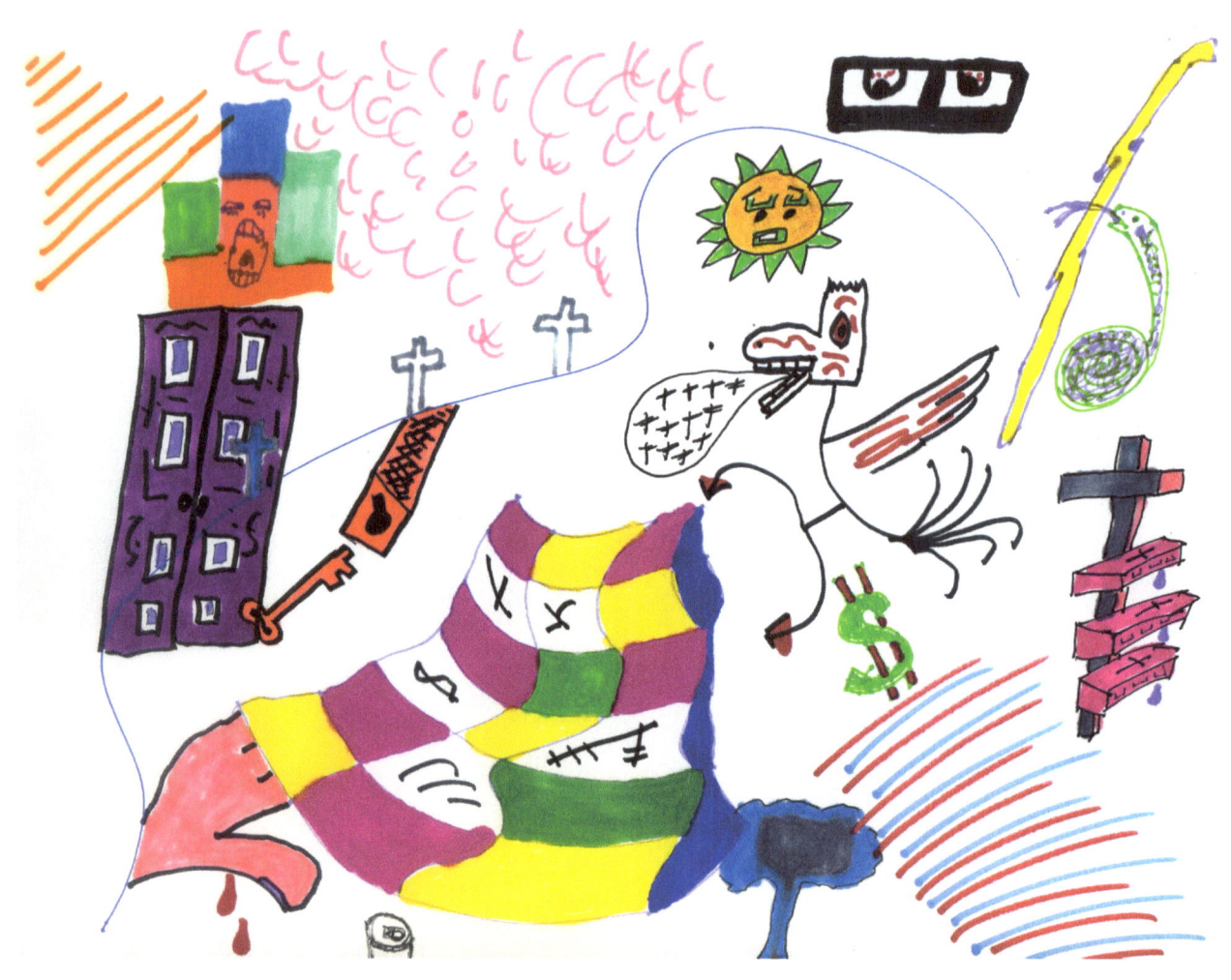

Abstract #17

ART

Abstract: Paper 53 #2

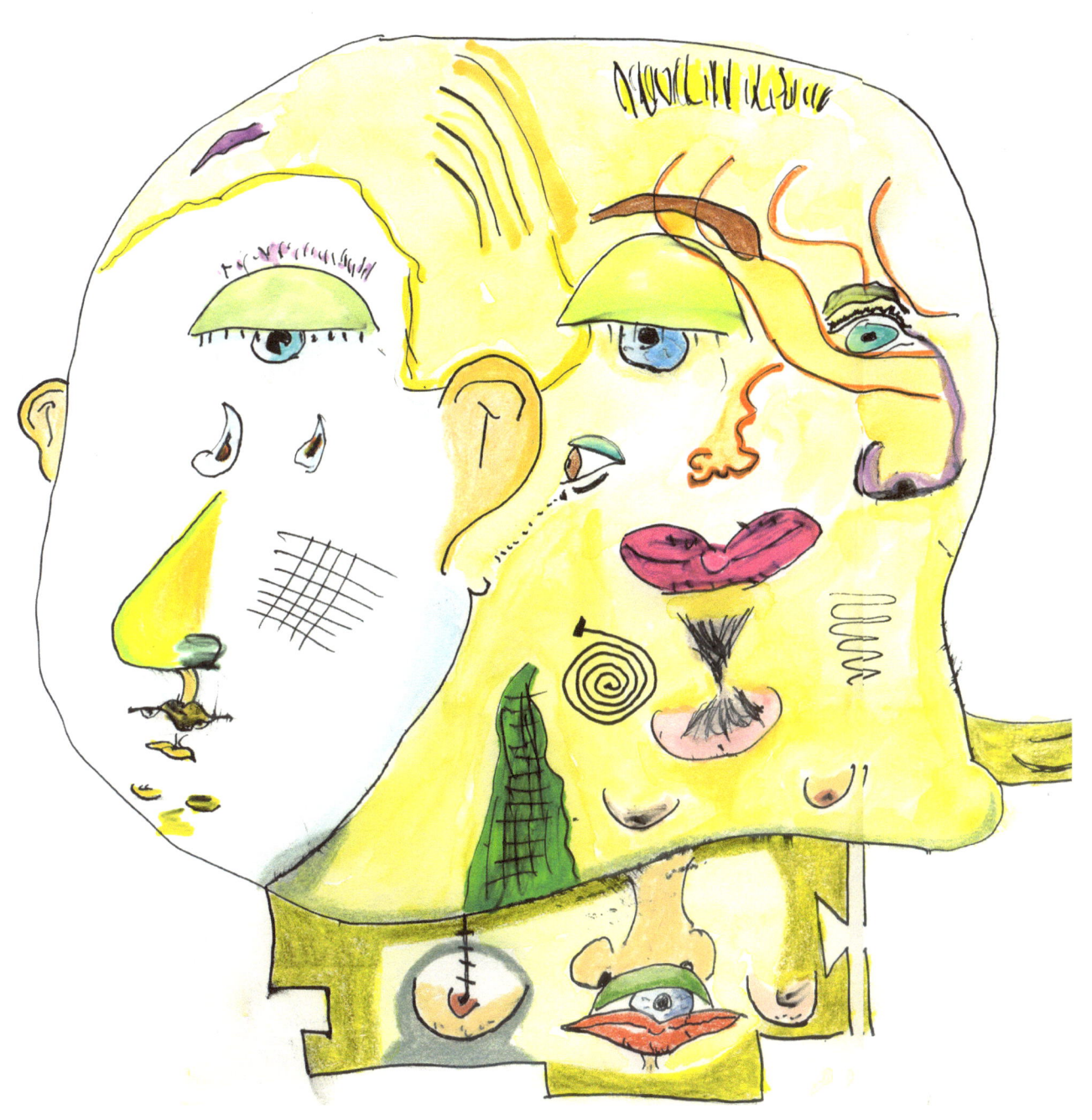

Abstract #57

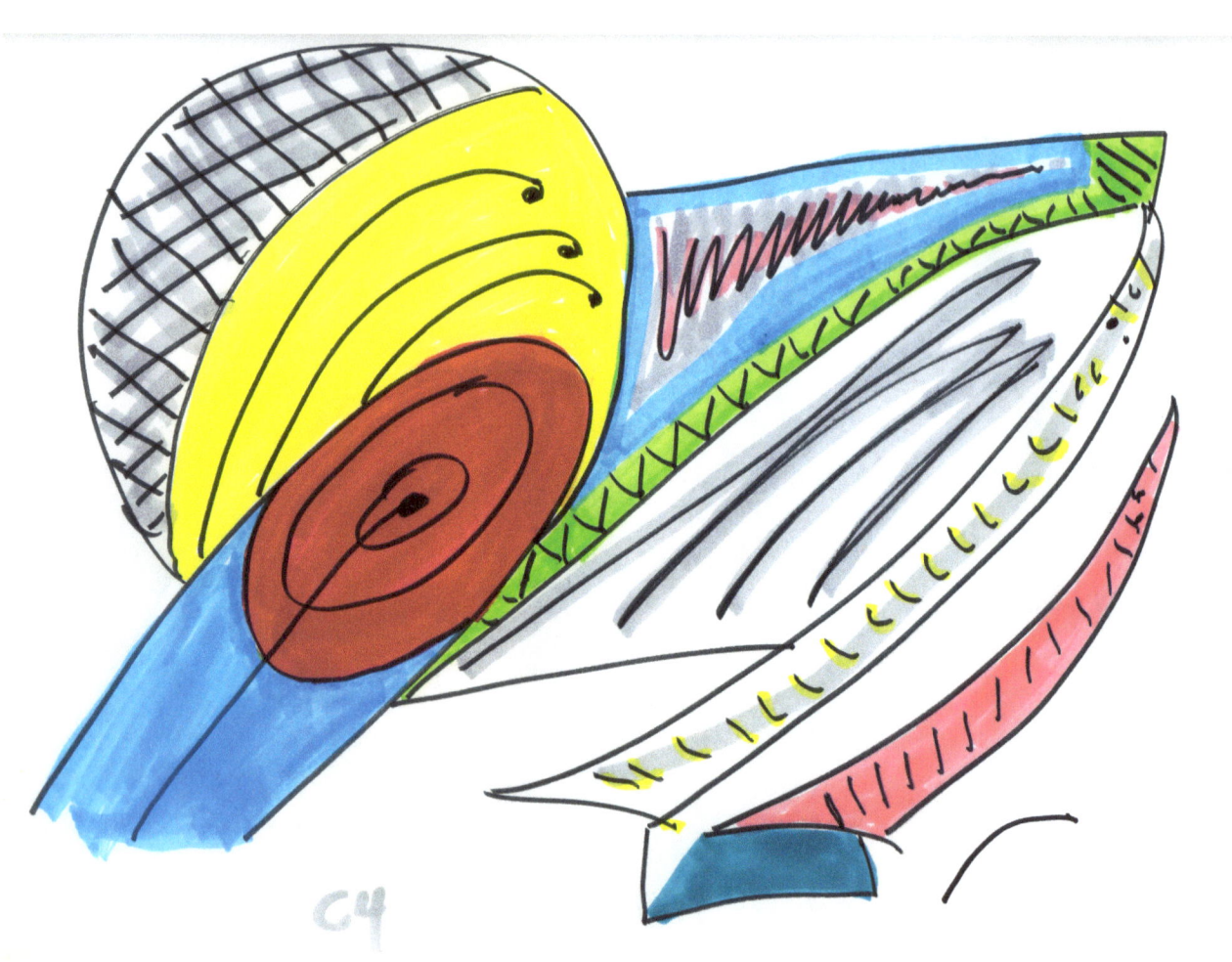

C4

Abstract: Paper 53 #3

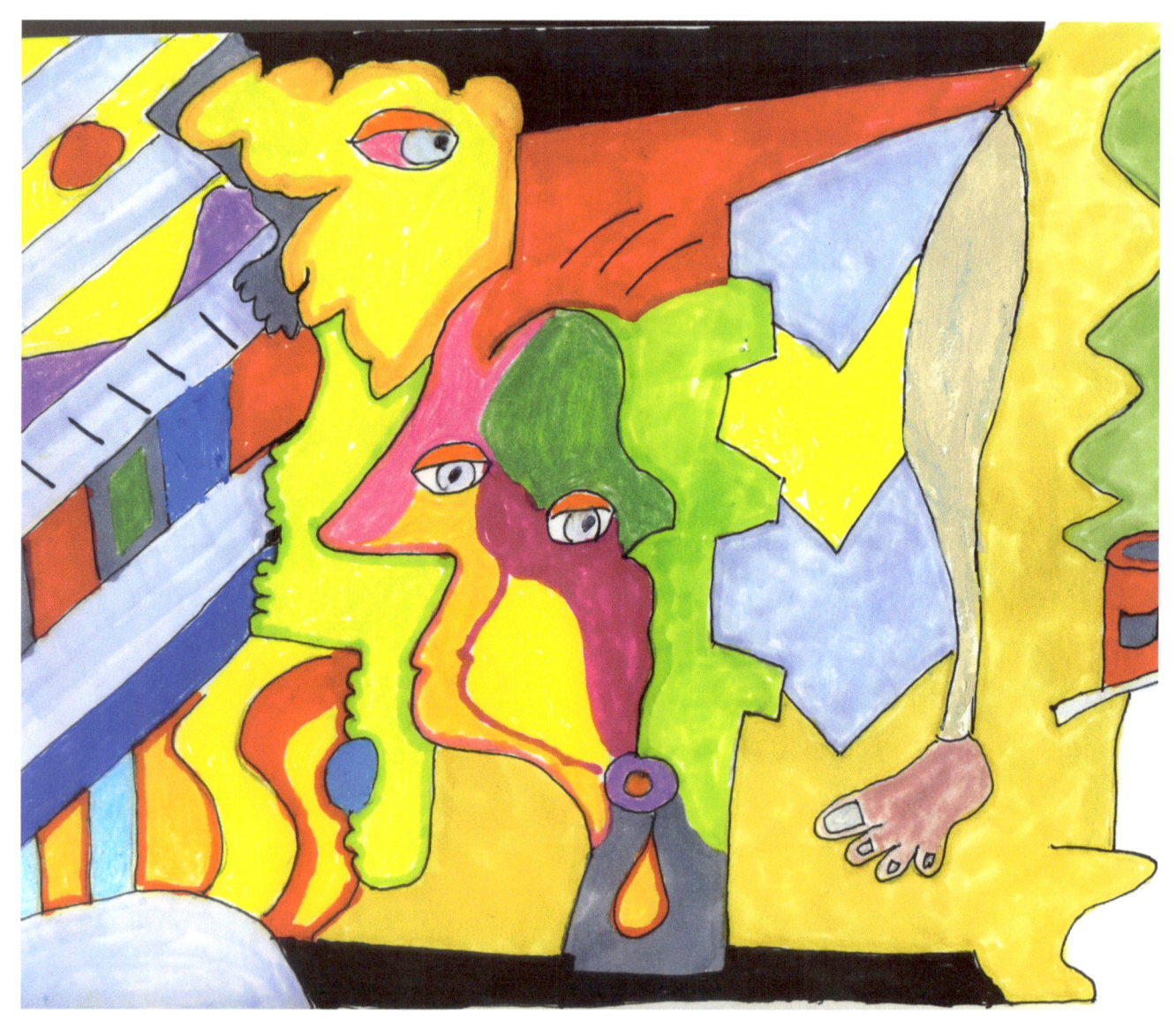

Abstract #42

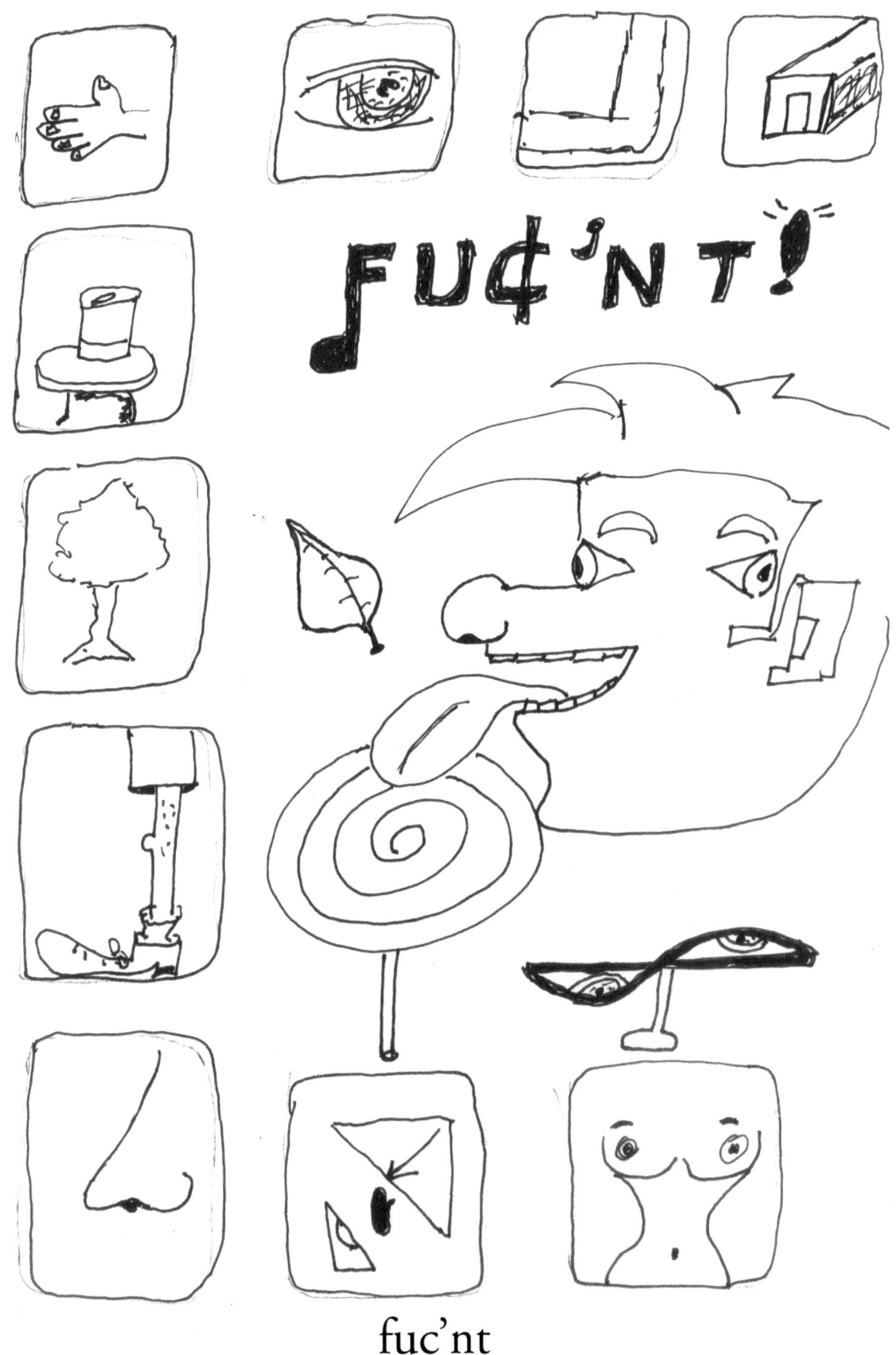

fuc'nt

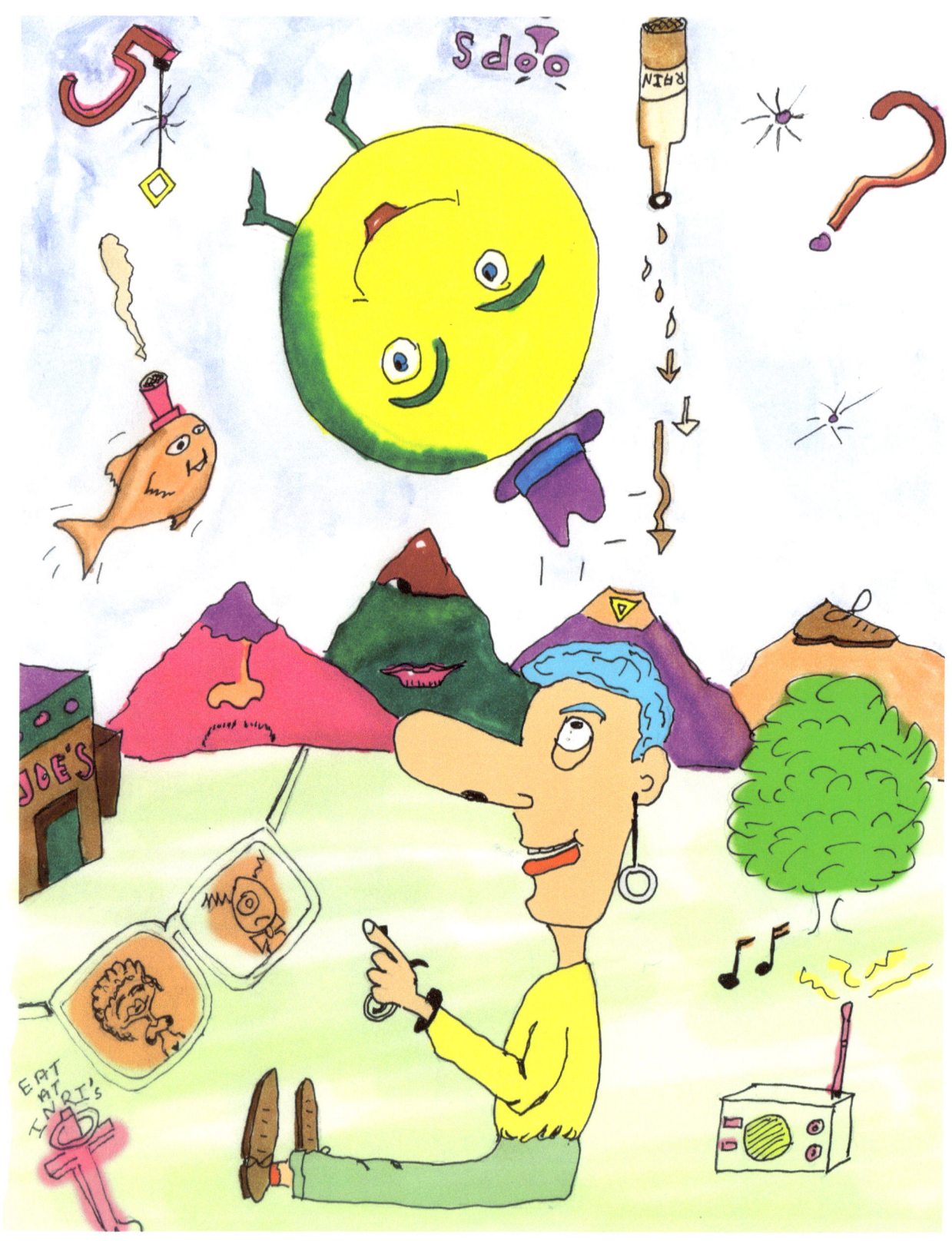

Summer

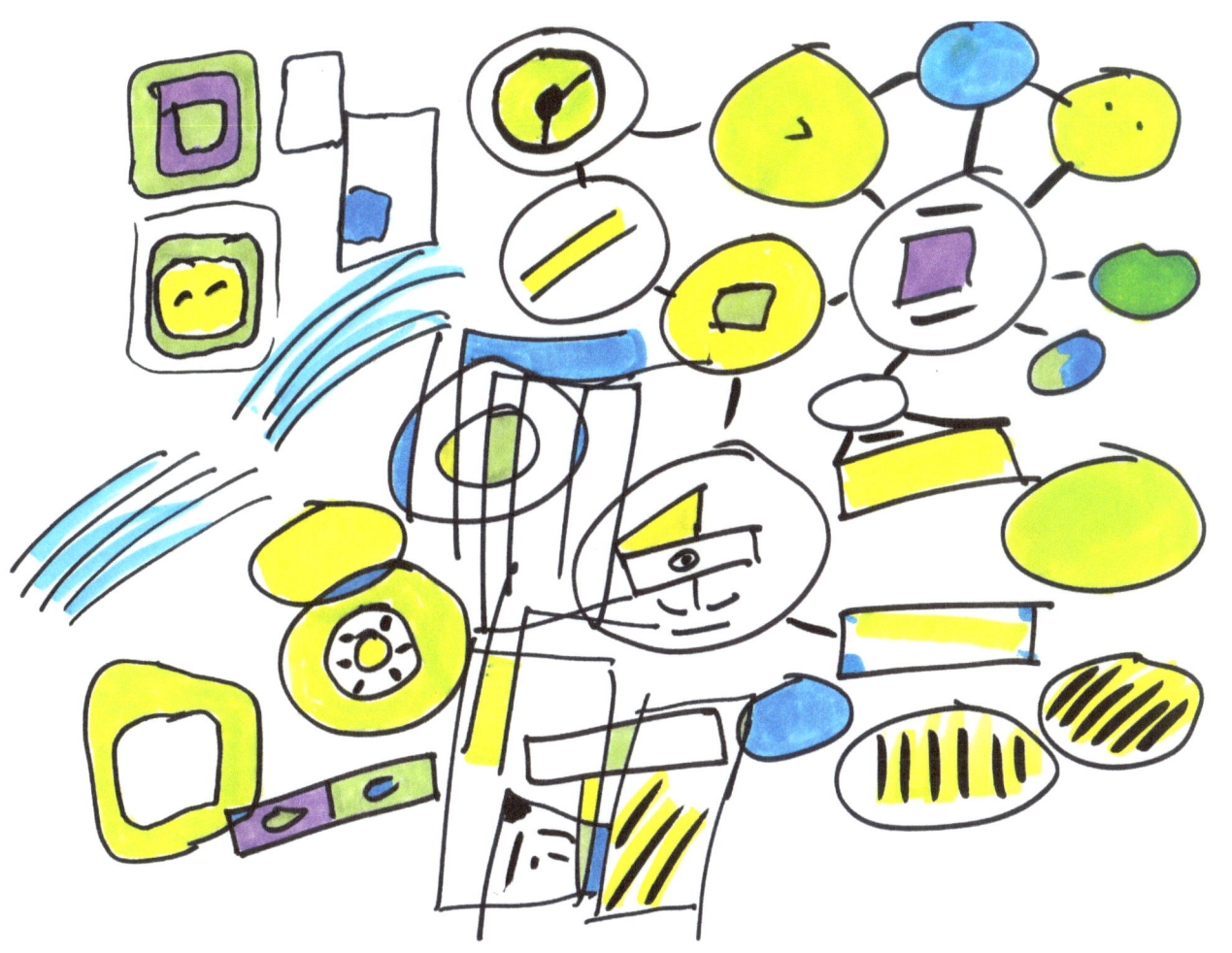

Connections

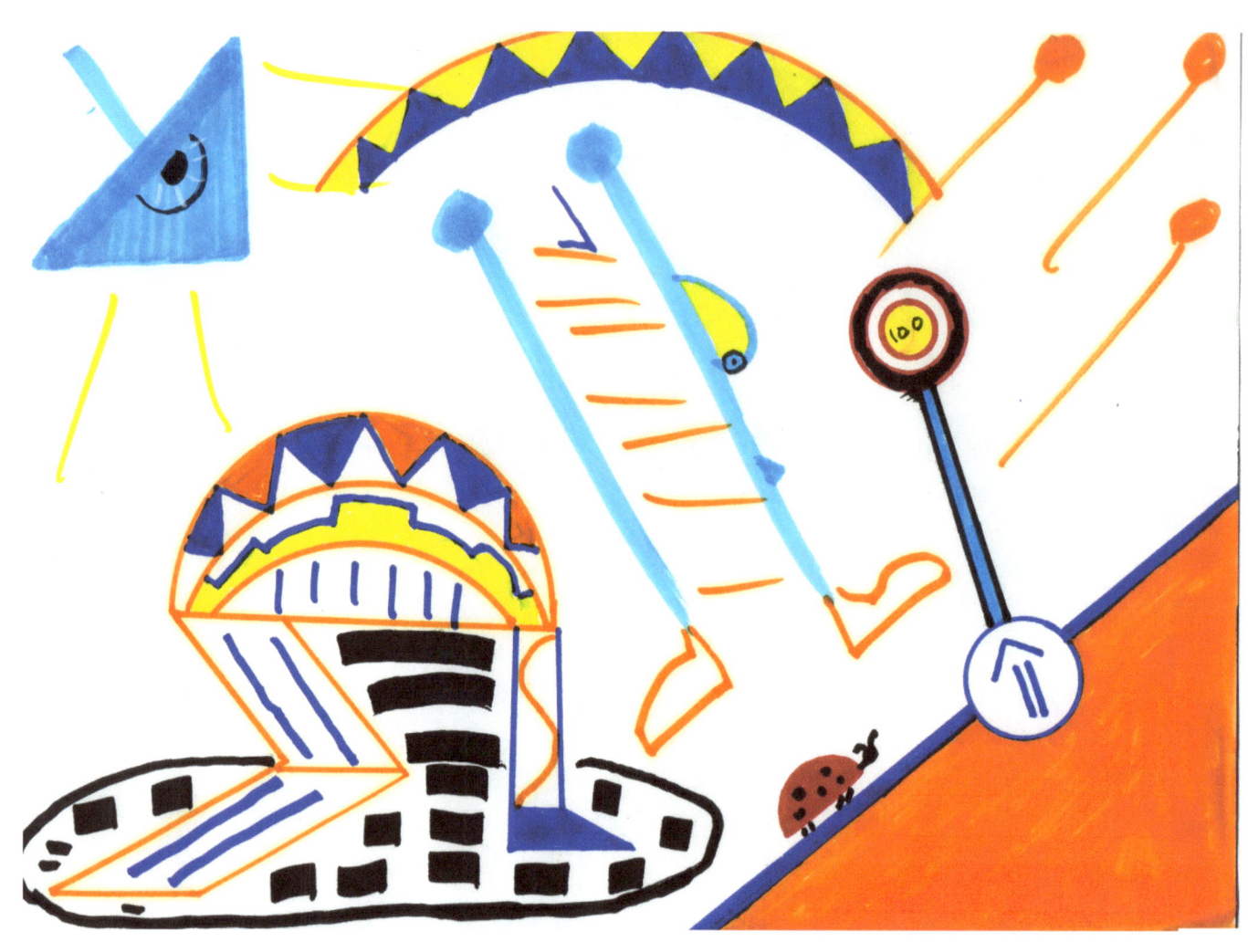

Mexico City #1

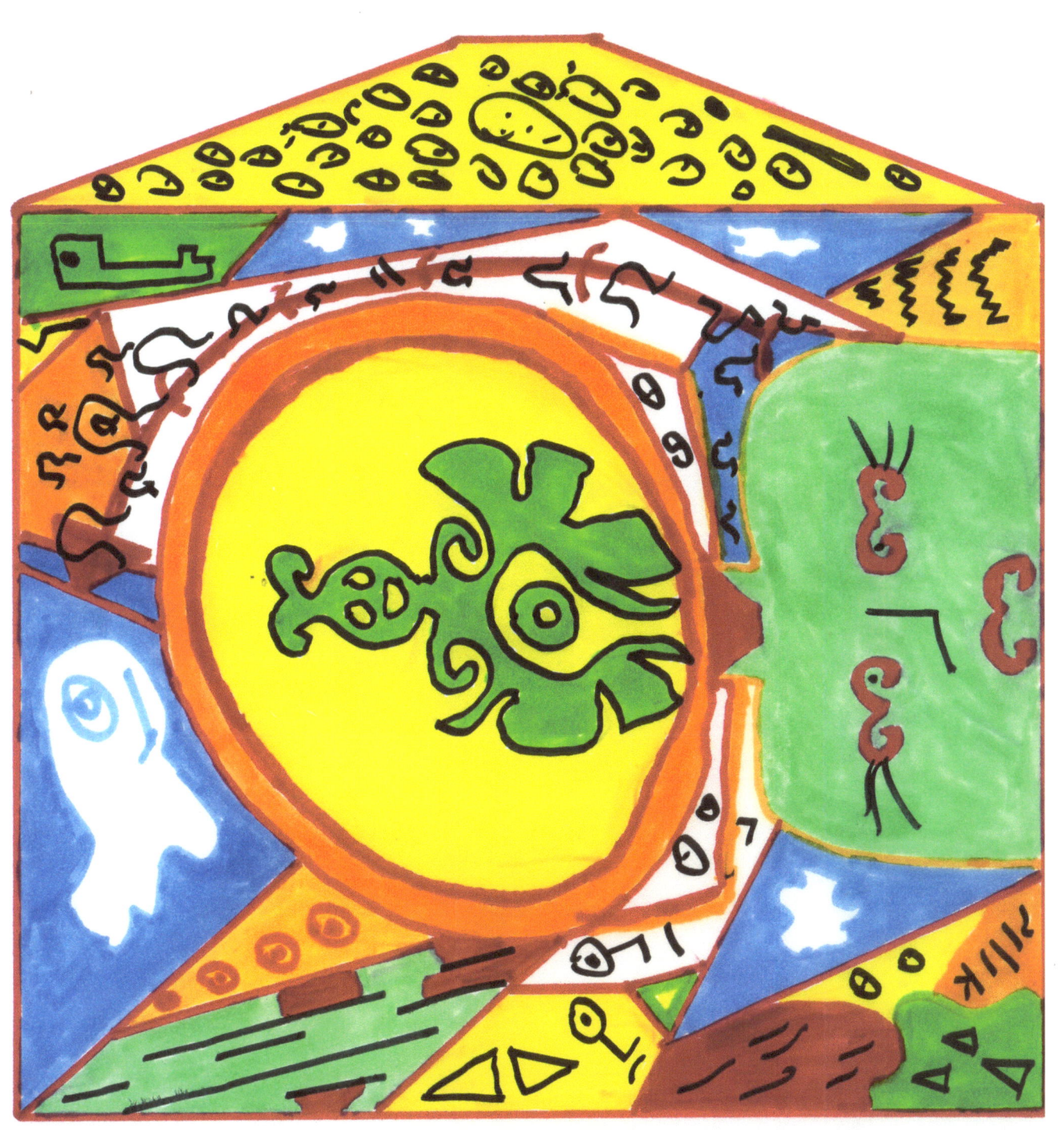

Mexico City #2

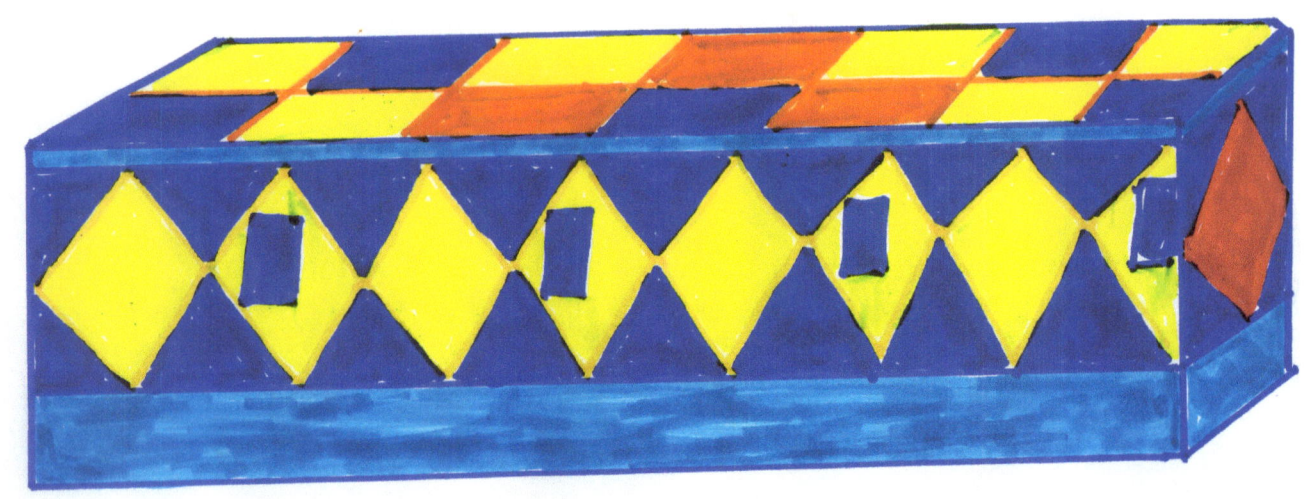

Mexico City #3

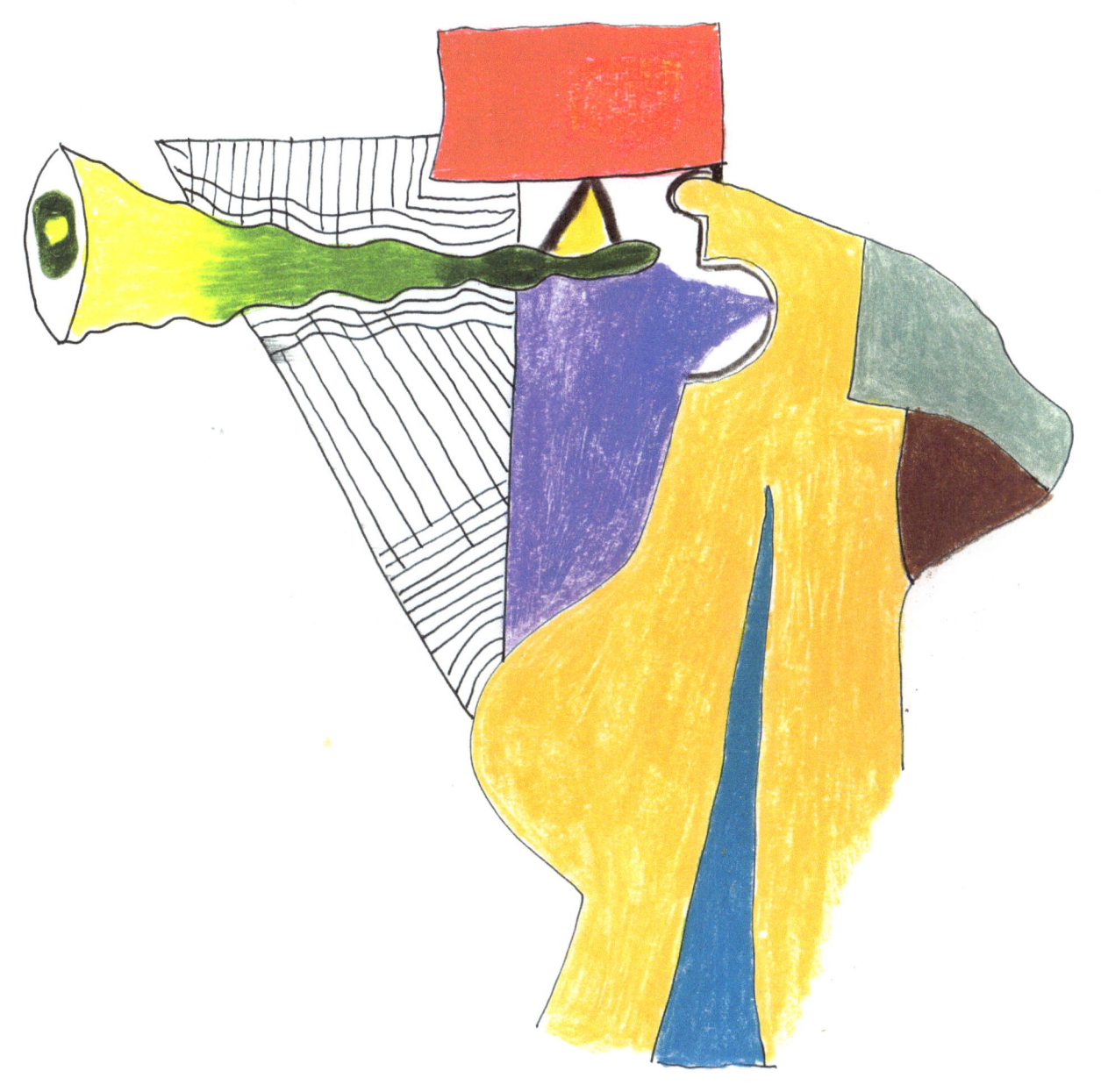

Abstract 42

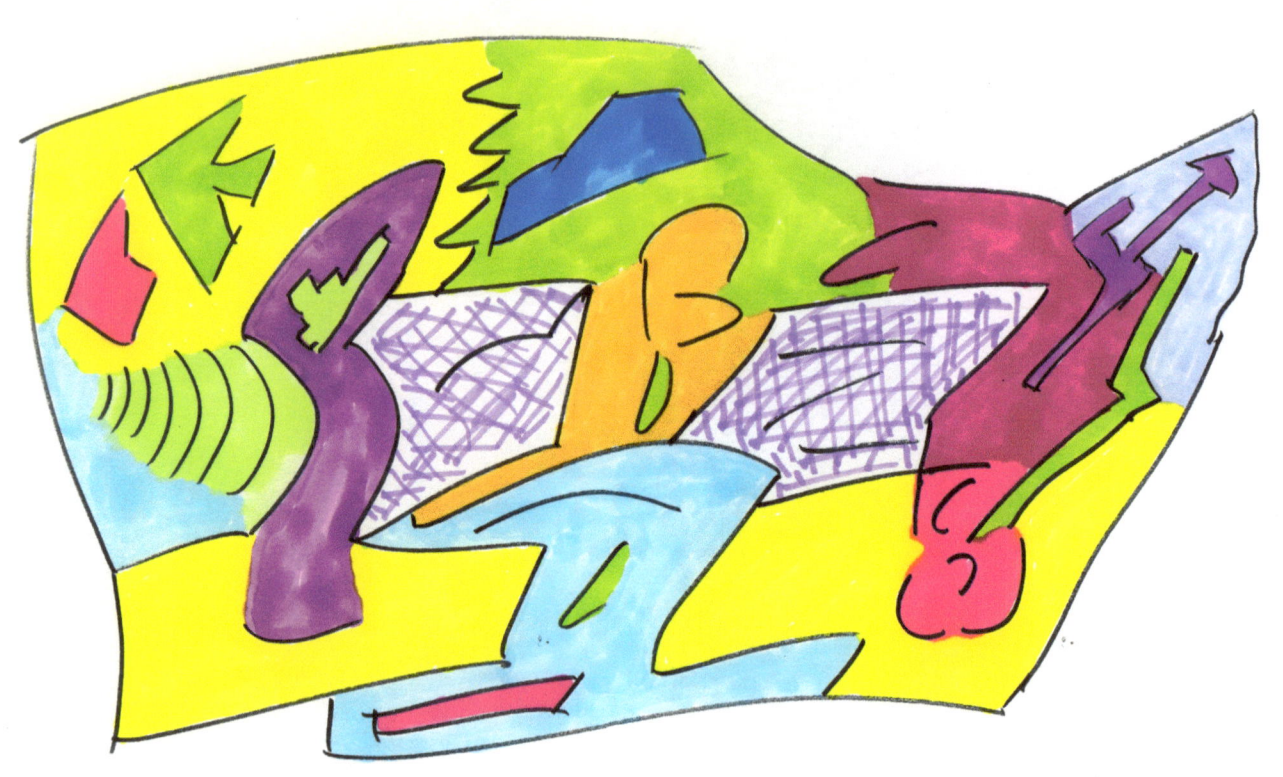

Abstract 31

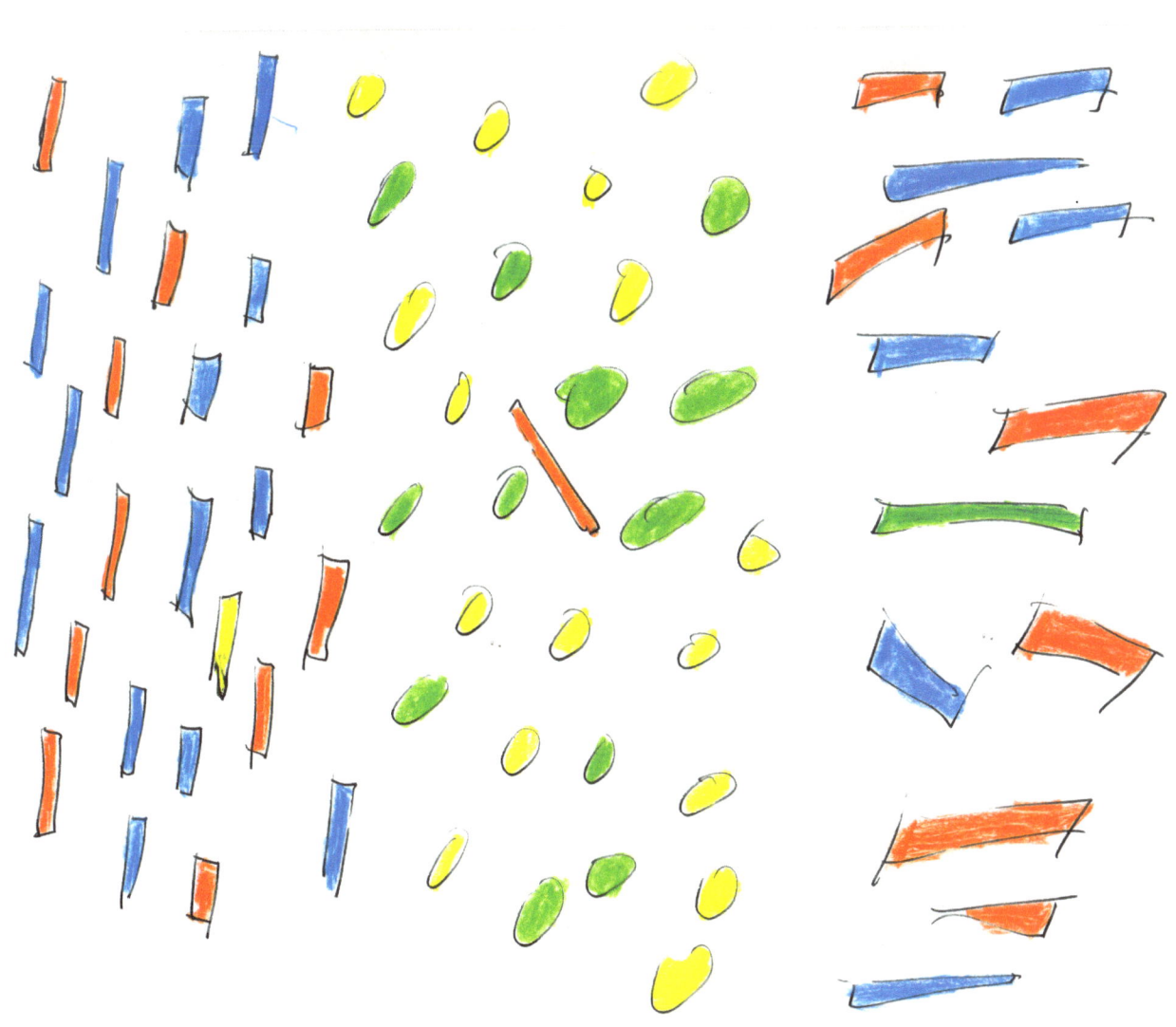

Abstract #20

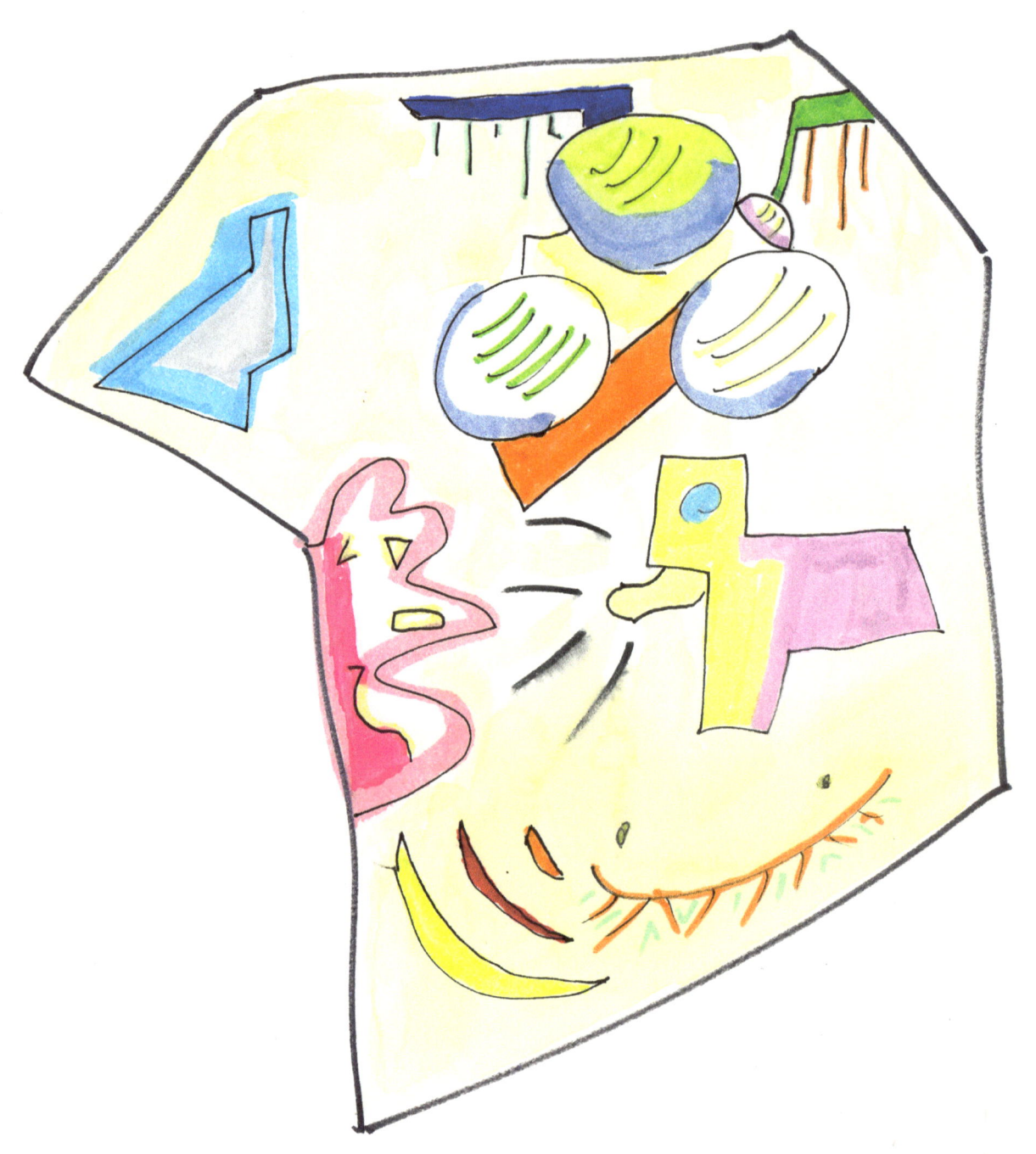

Abstract #17

GROSZ STYLE

George Grosz (July 26, 1893 – July 6, 1959) was a German artist known especially for his caricatural drawings of decadent Berlin life in the 1920s.

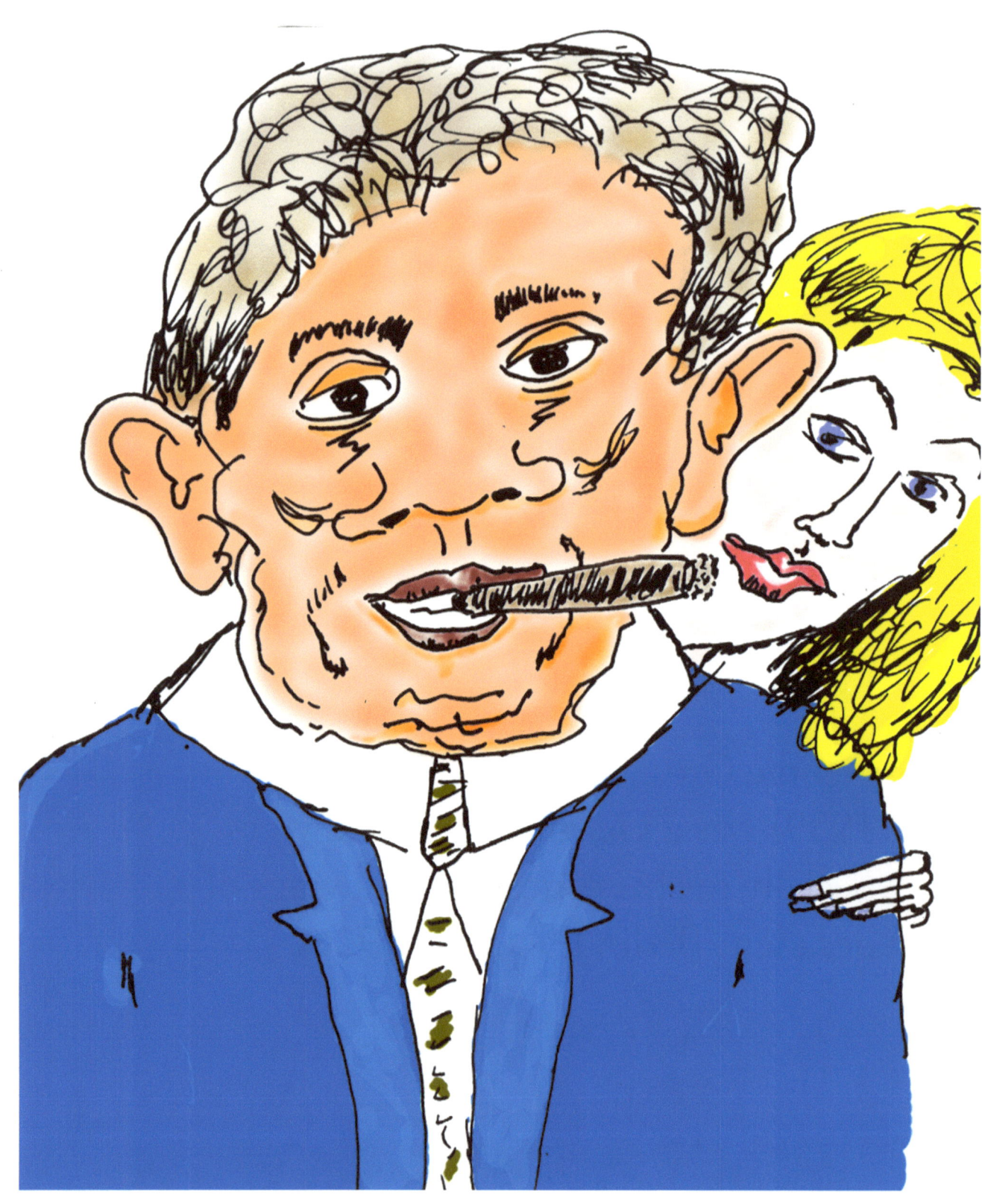

Power

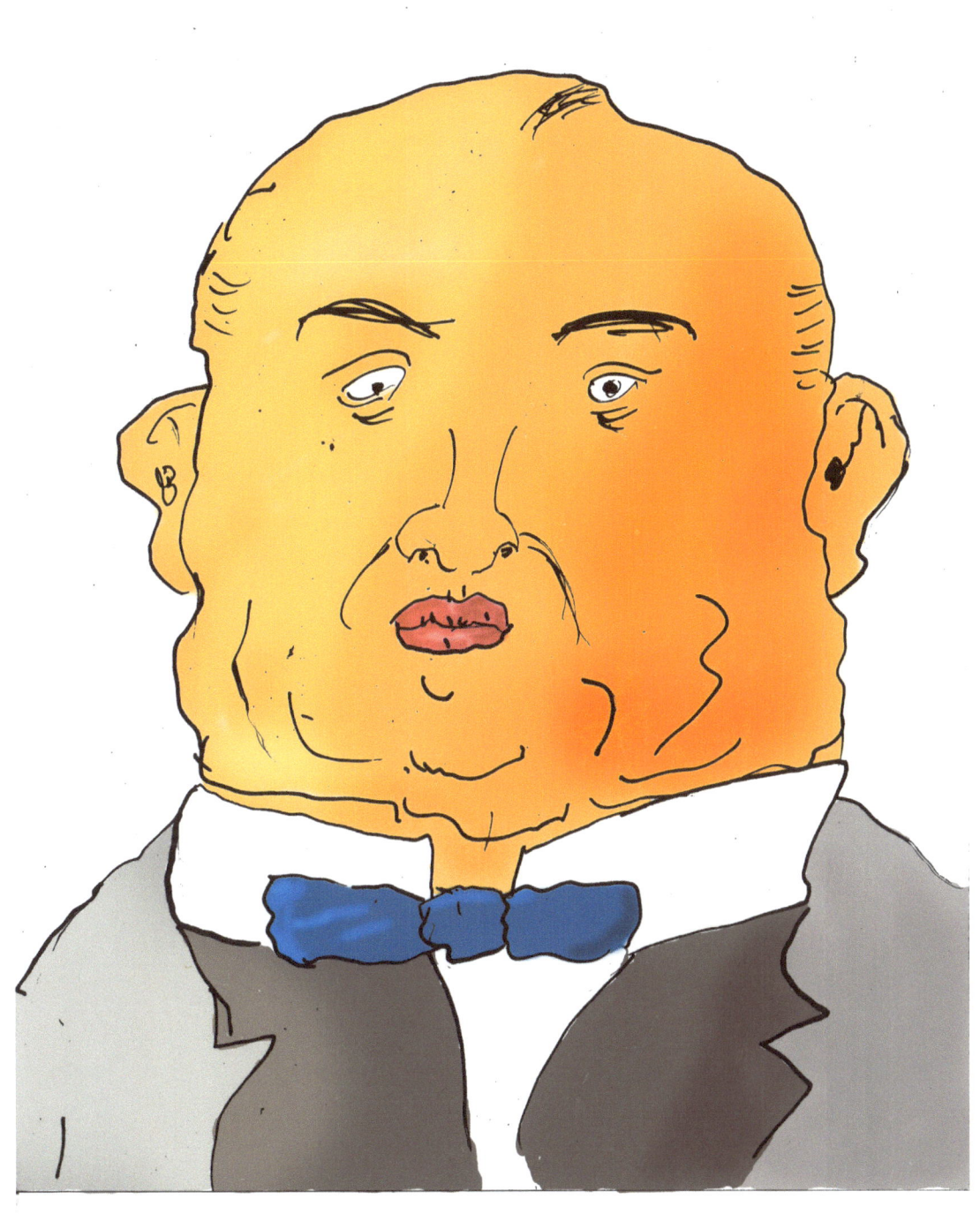

Never Enough

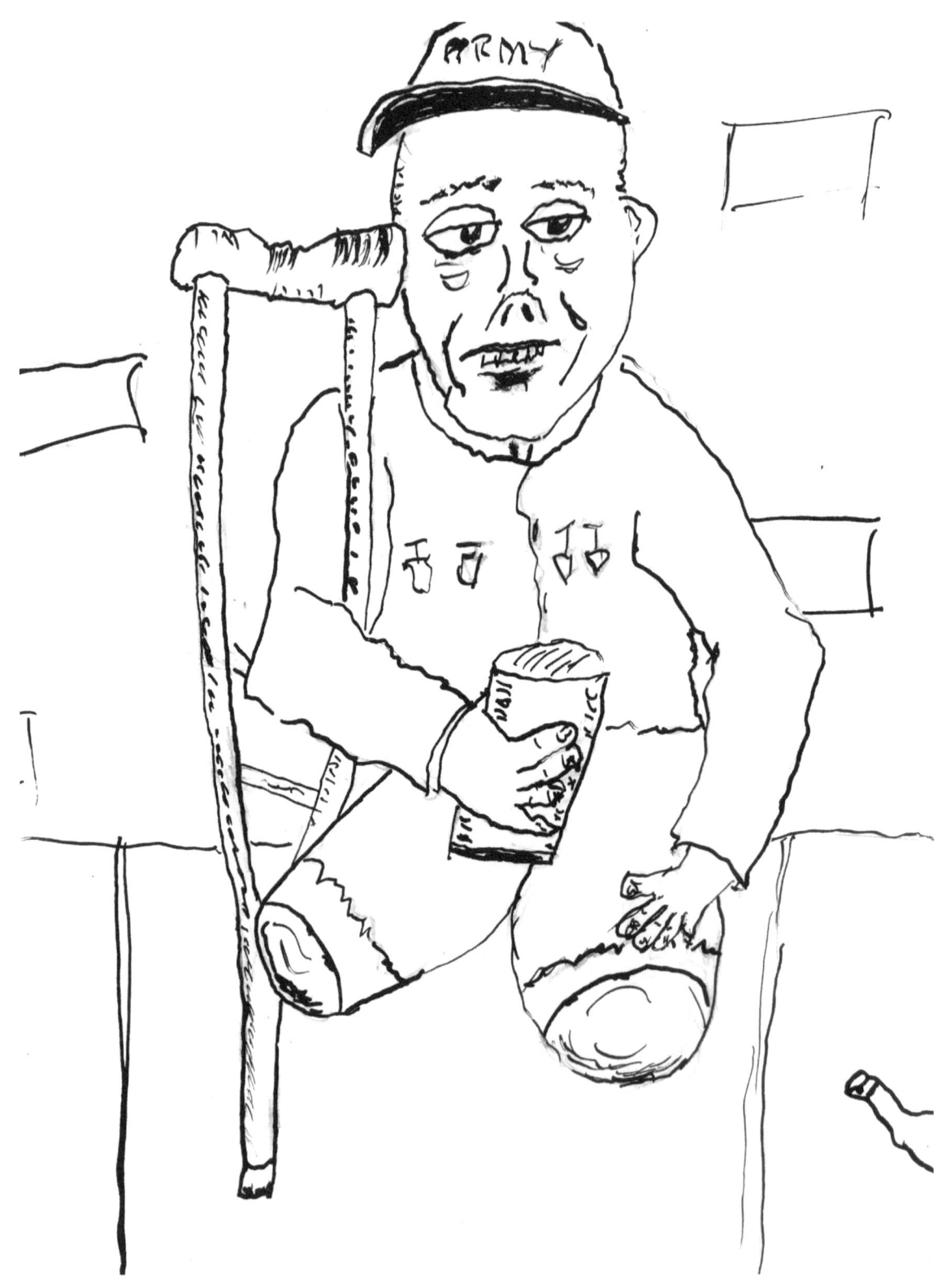

After The Flag Waving's Over

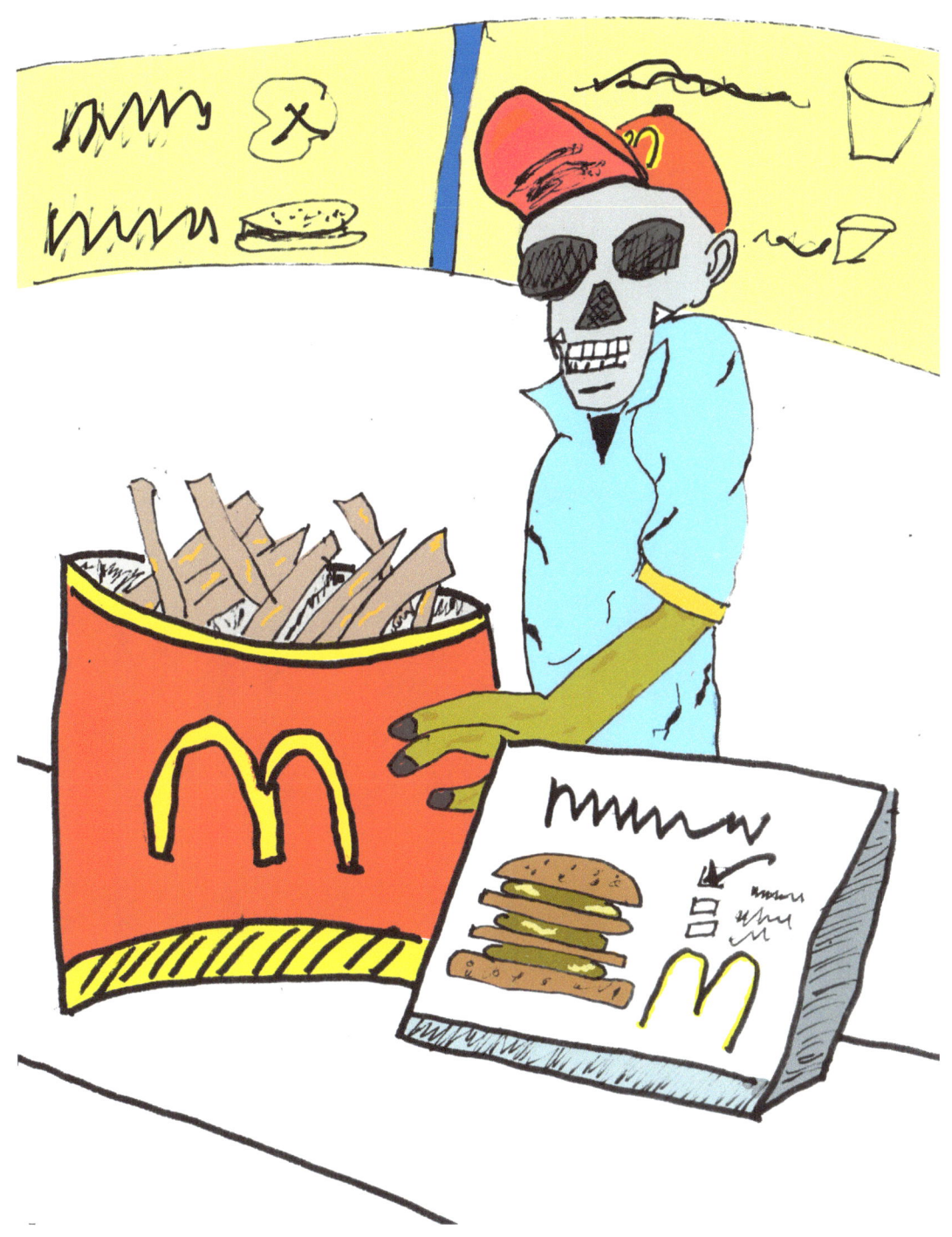

The Final Super Size

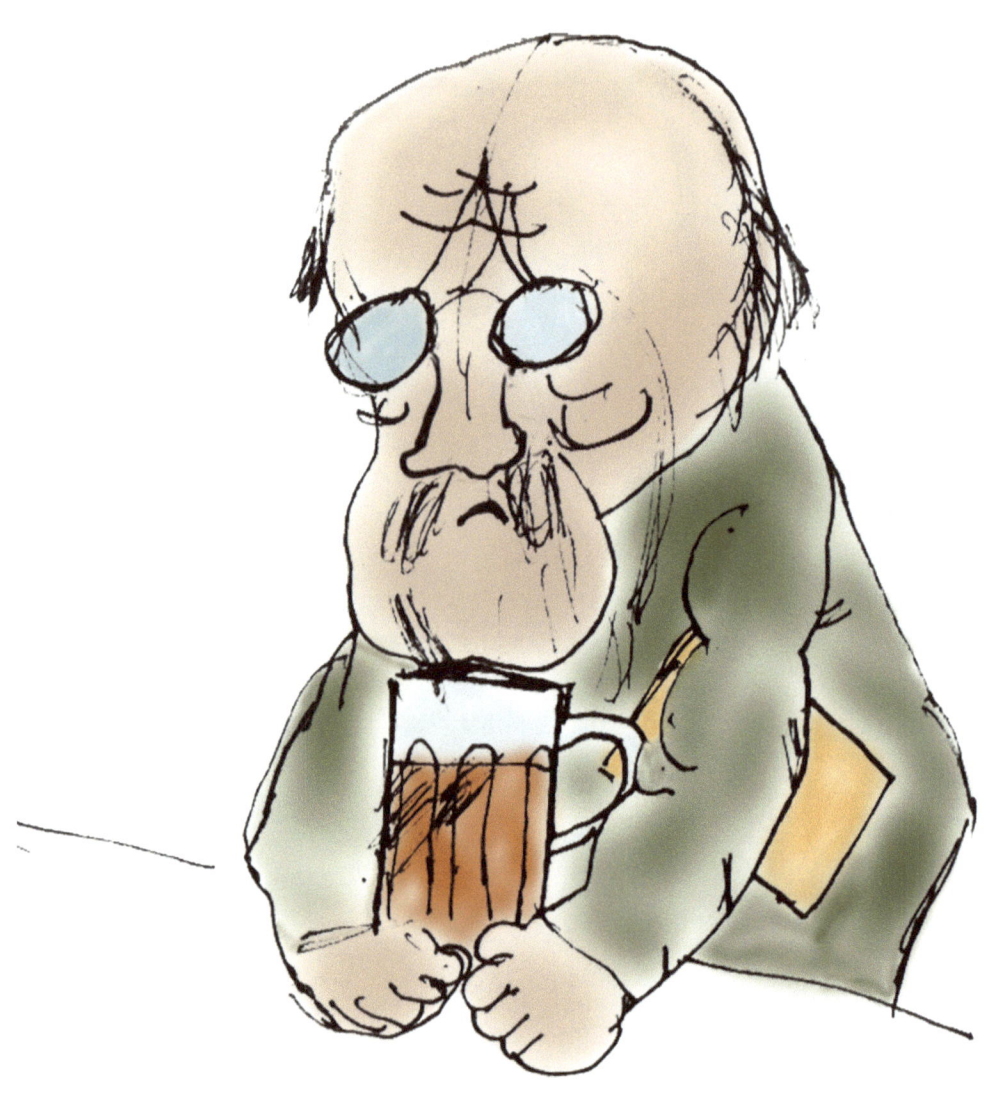

Berlin Beer

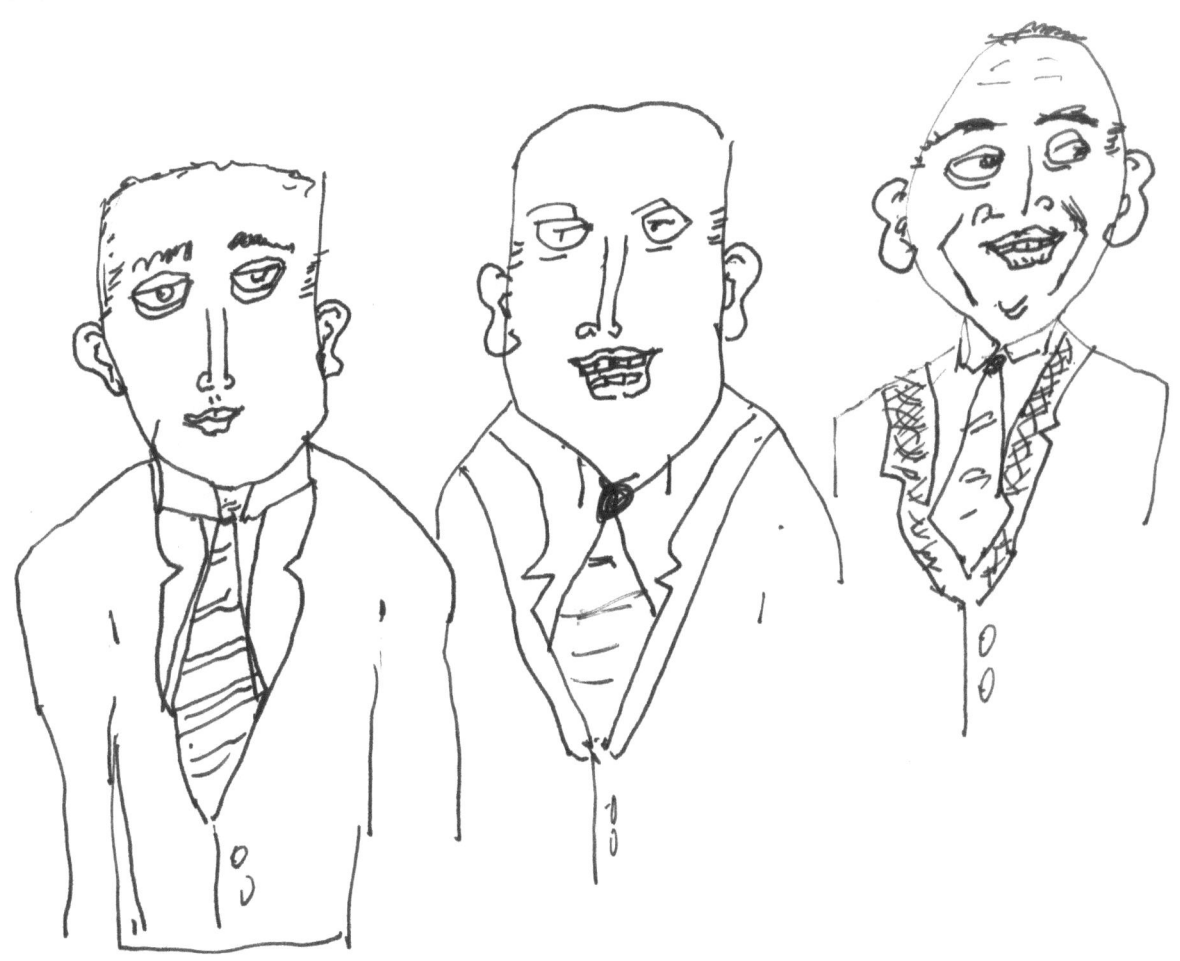

At Your Service

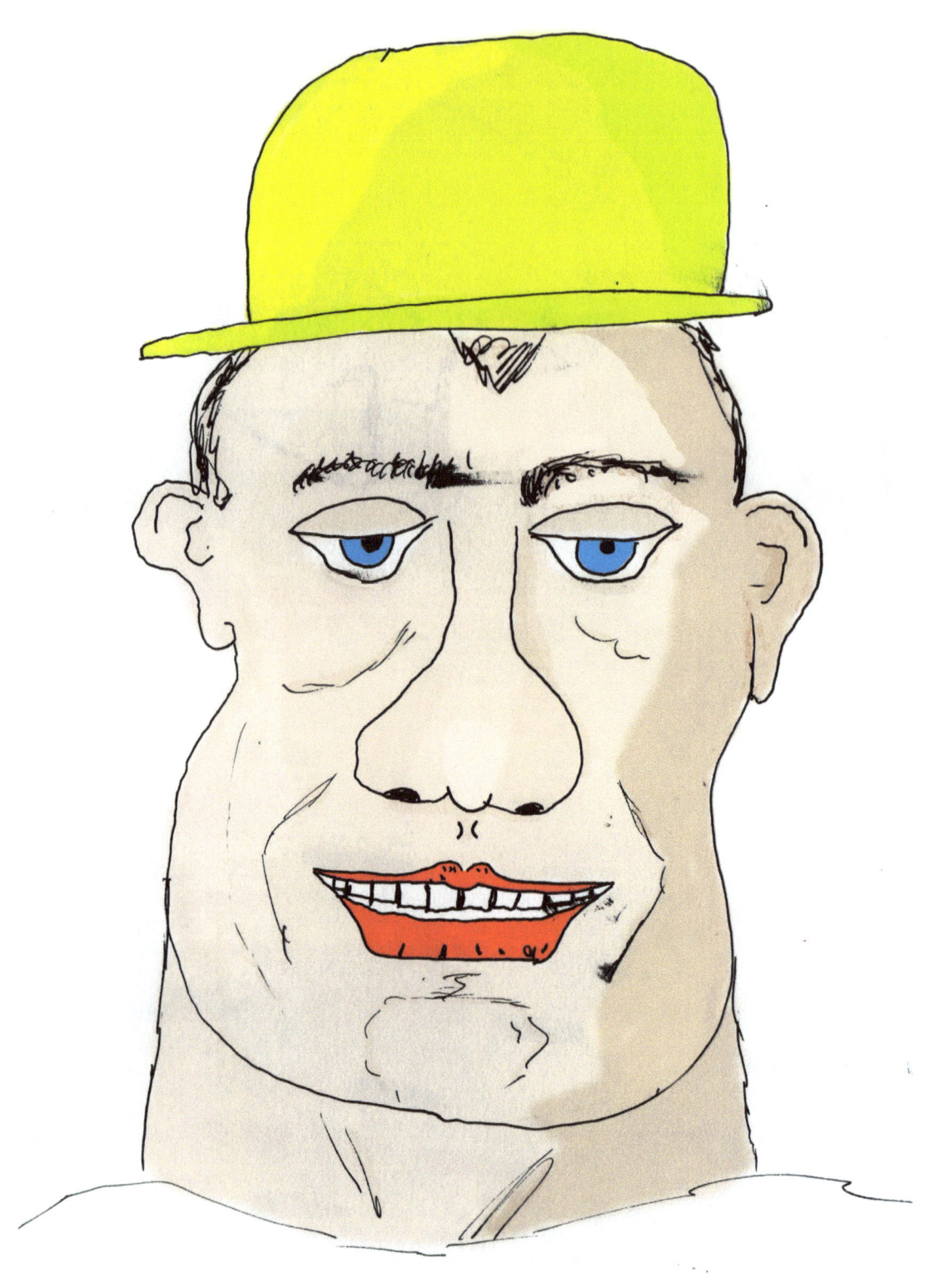

Steamfitter

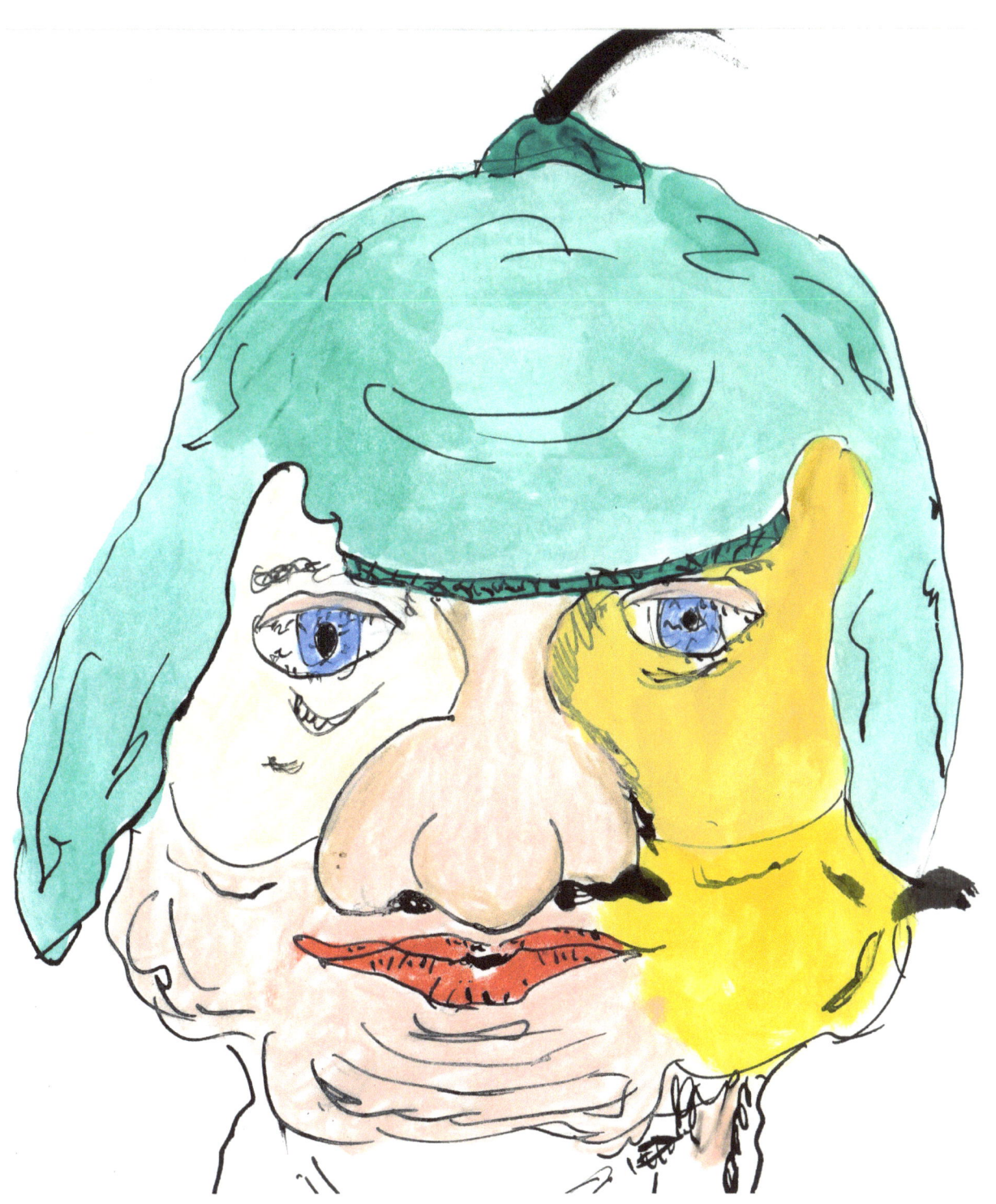

Dee

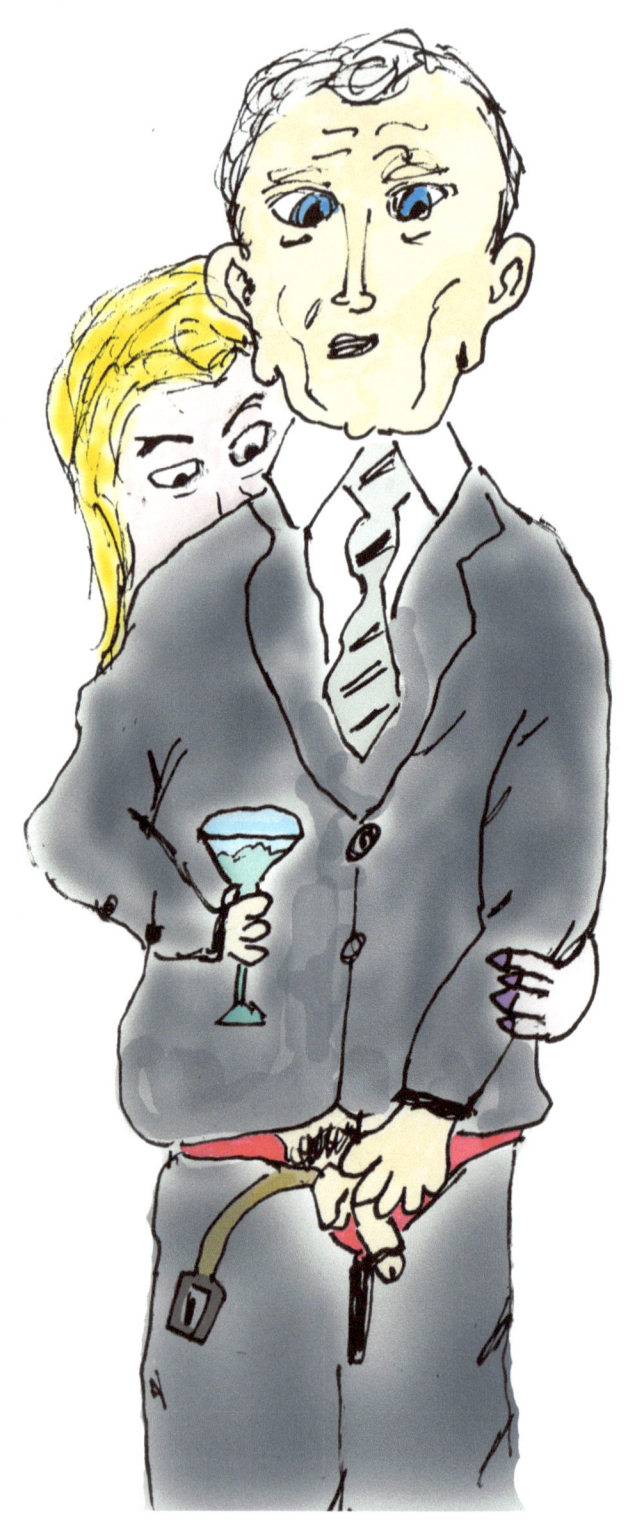

Wall Street Guy

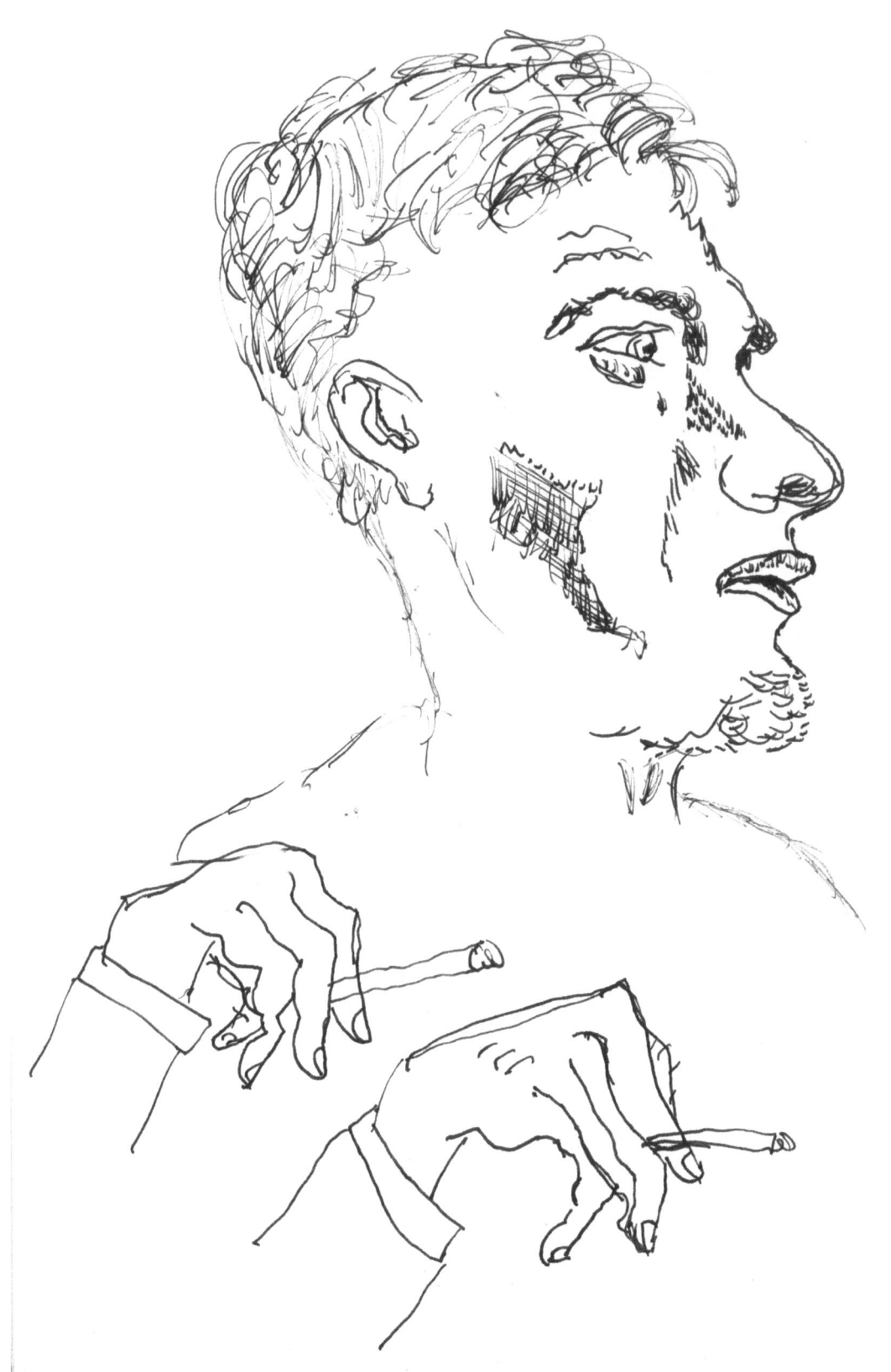

Smoker's Dream

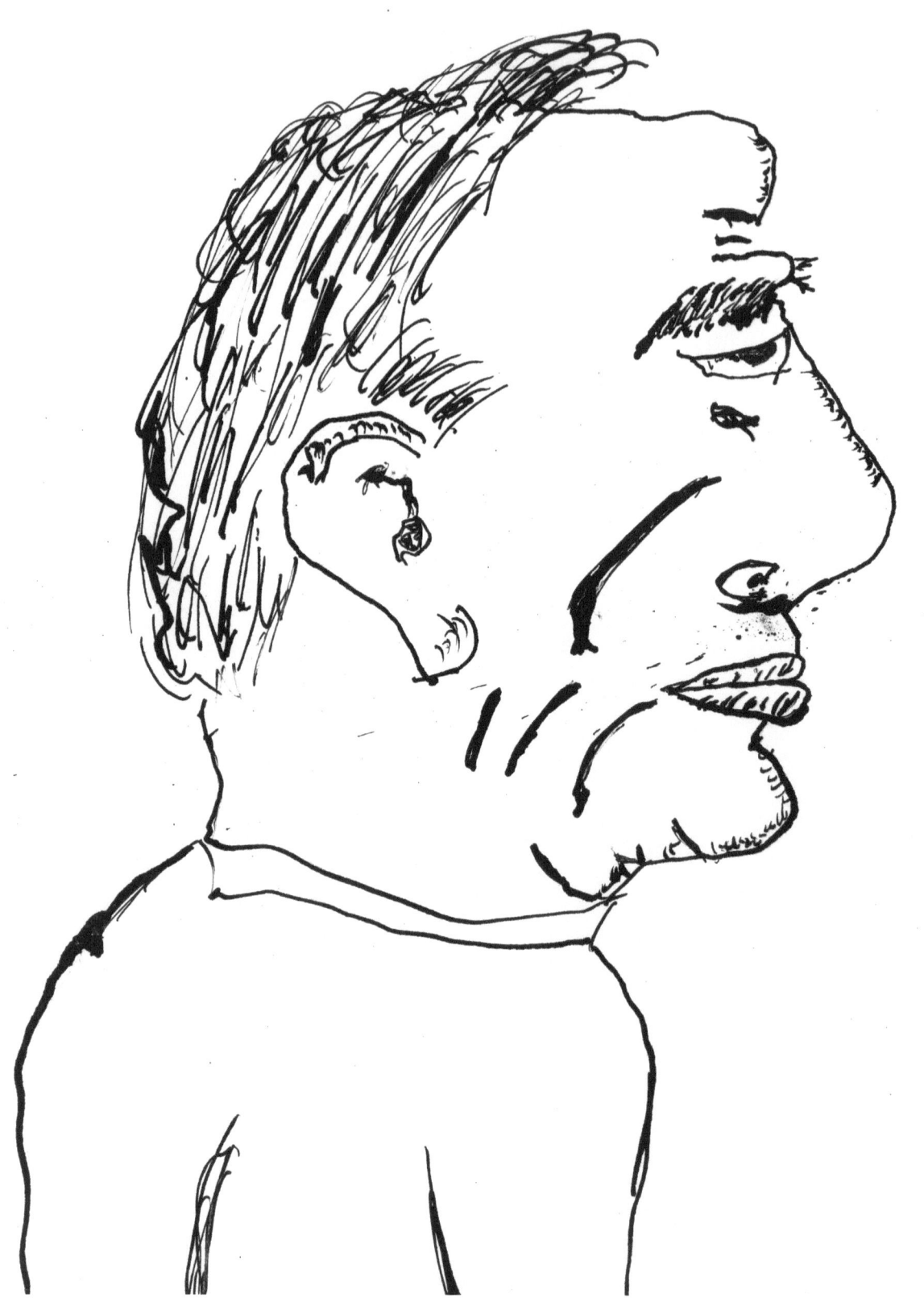

Man #7

People, Places & Esoterica

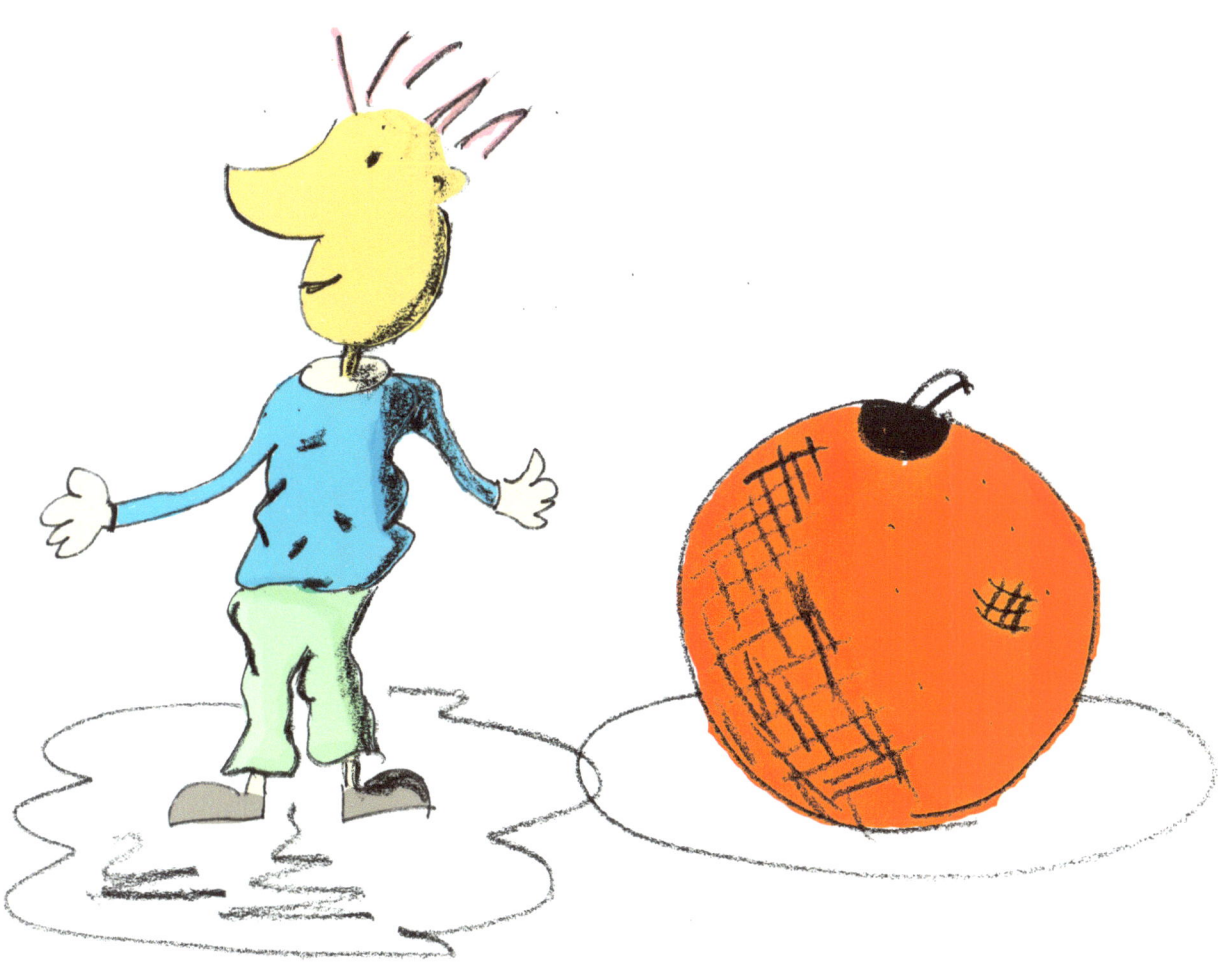

Boy

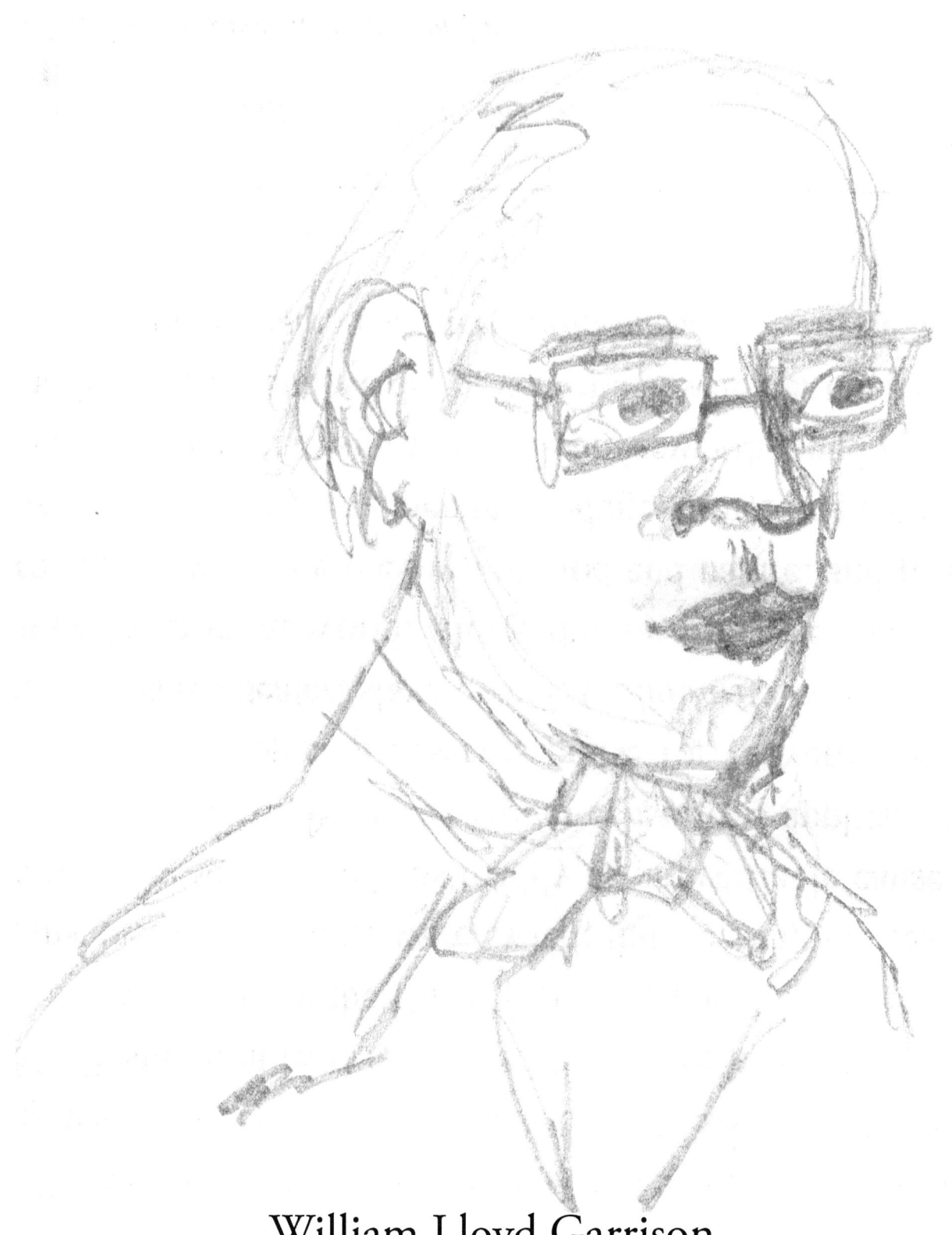

William Lloyd Garrison
(December 12, 1805 – May 24, 1879)

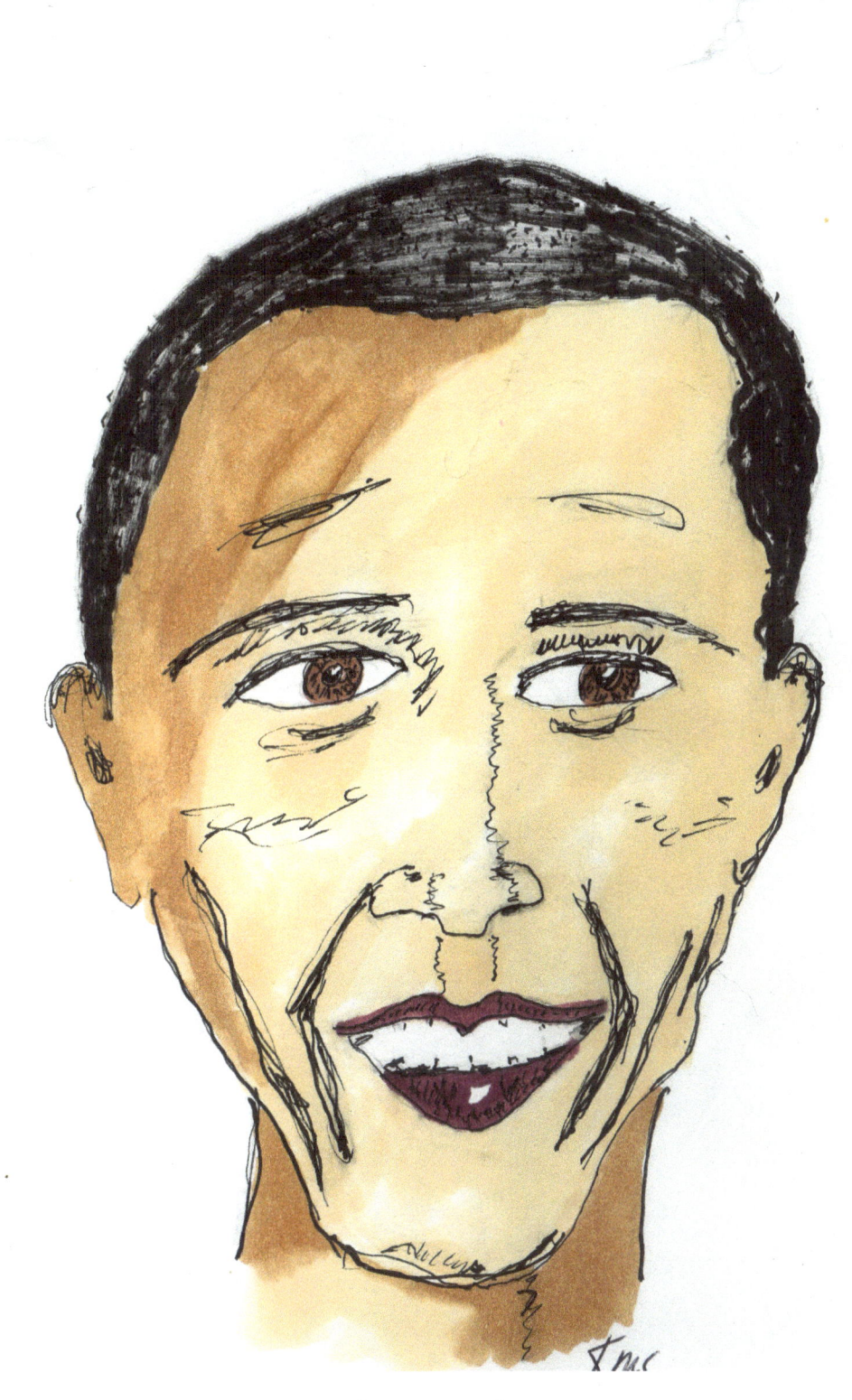

President Obama

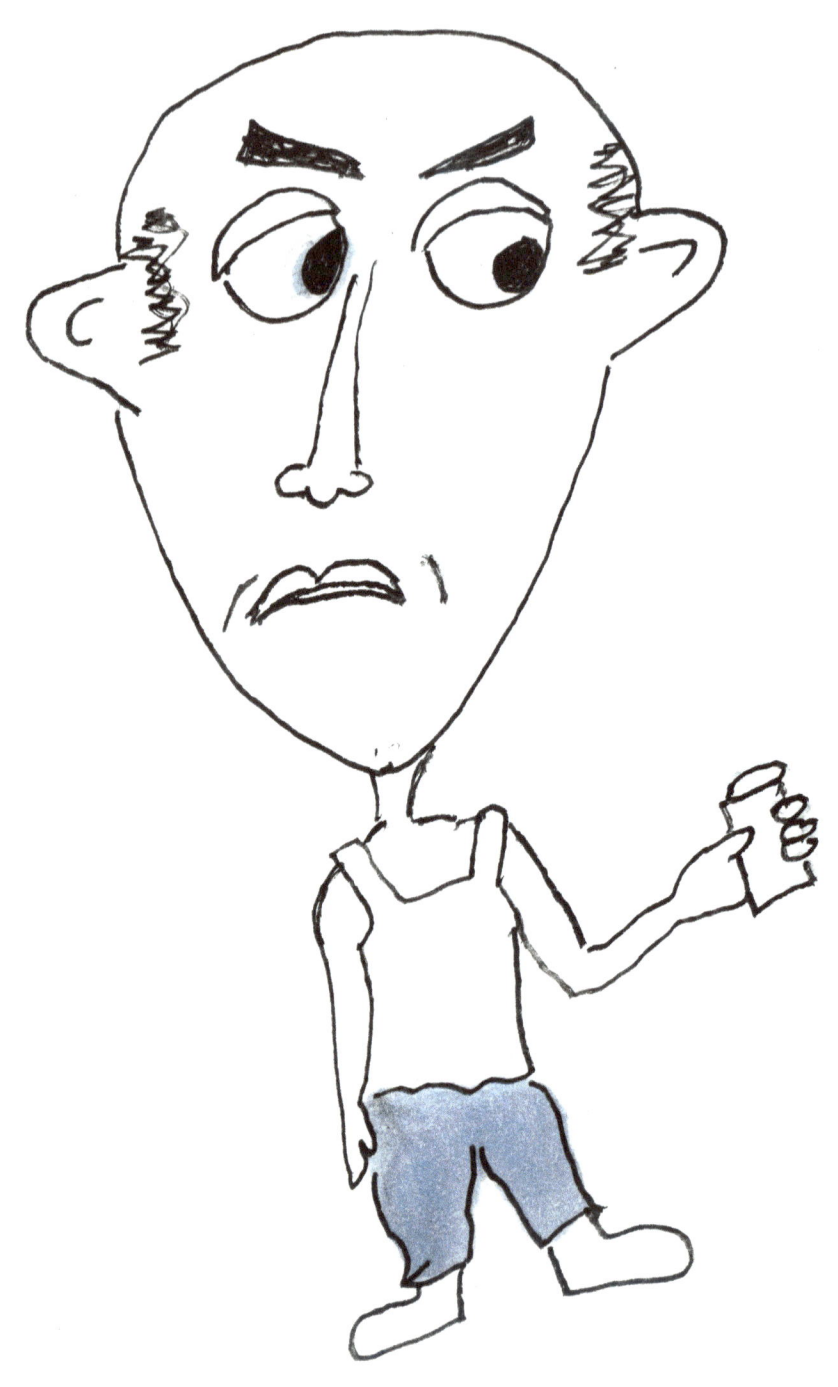

Deadbeat Dad

LACK OF IDEALS = CONFORMITY……………………

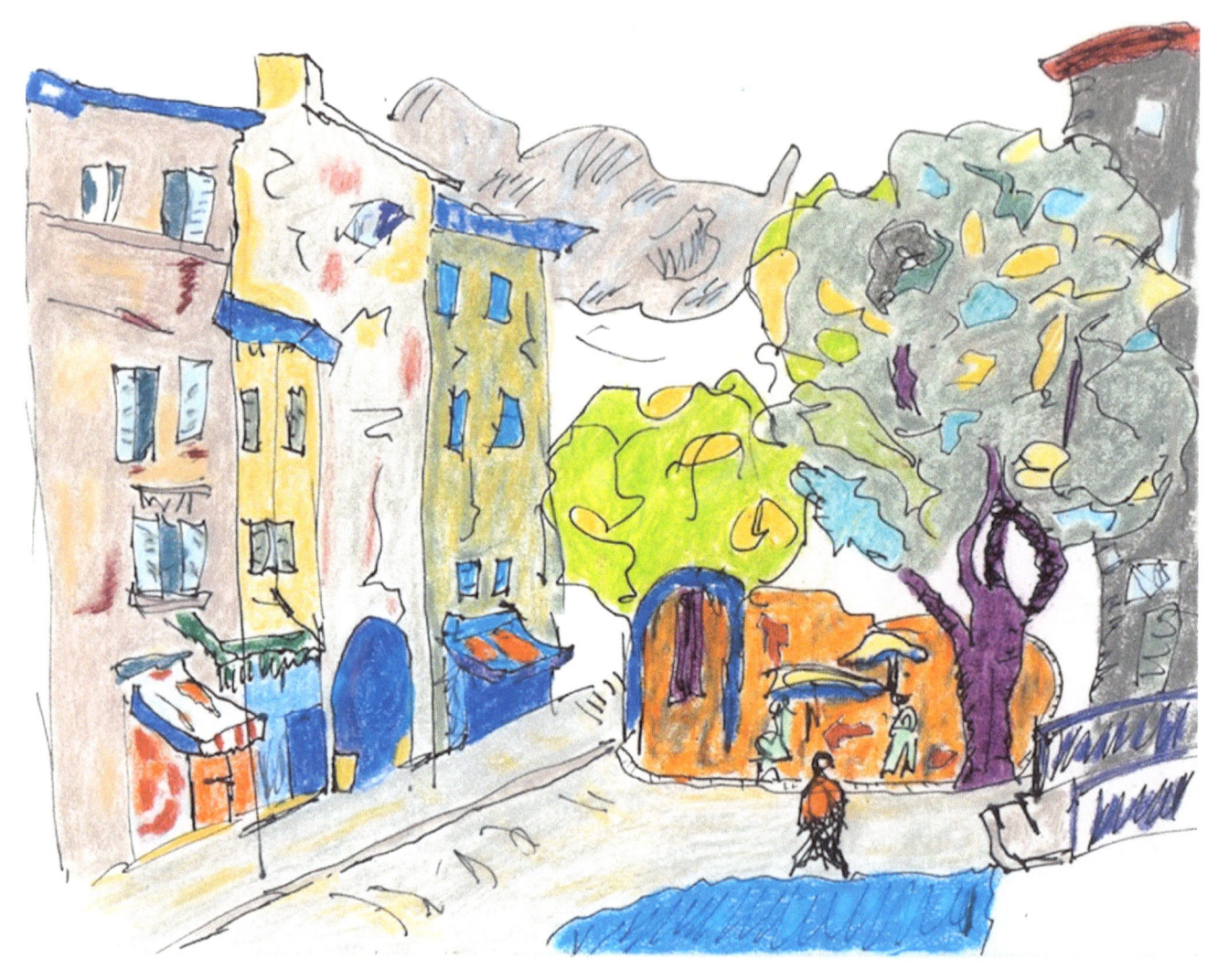

Paris Street #1

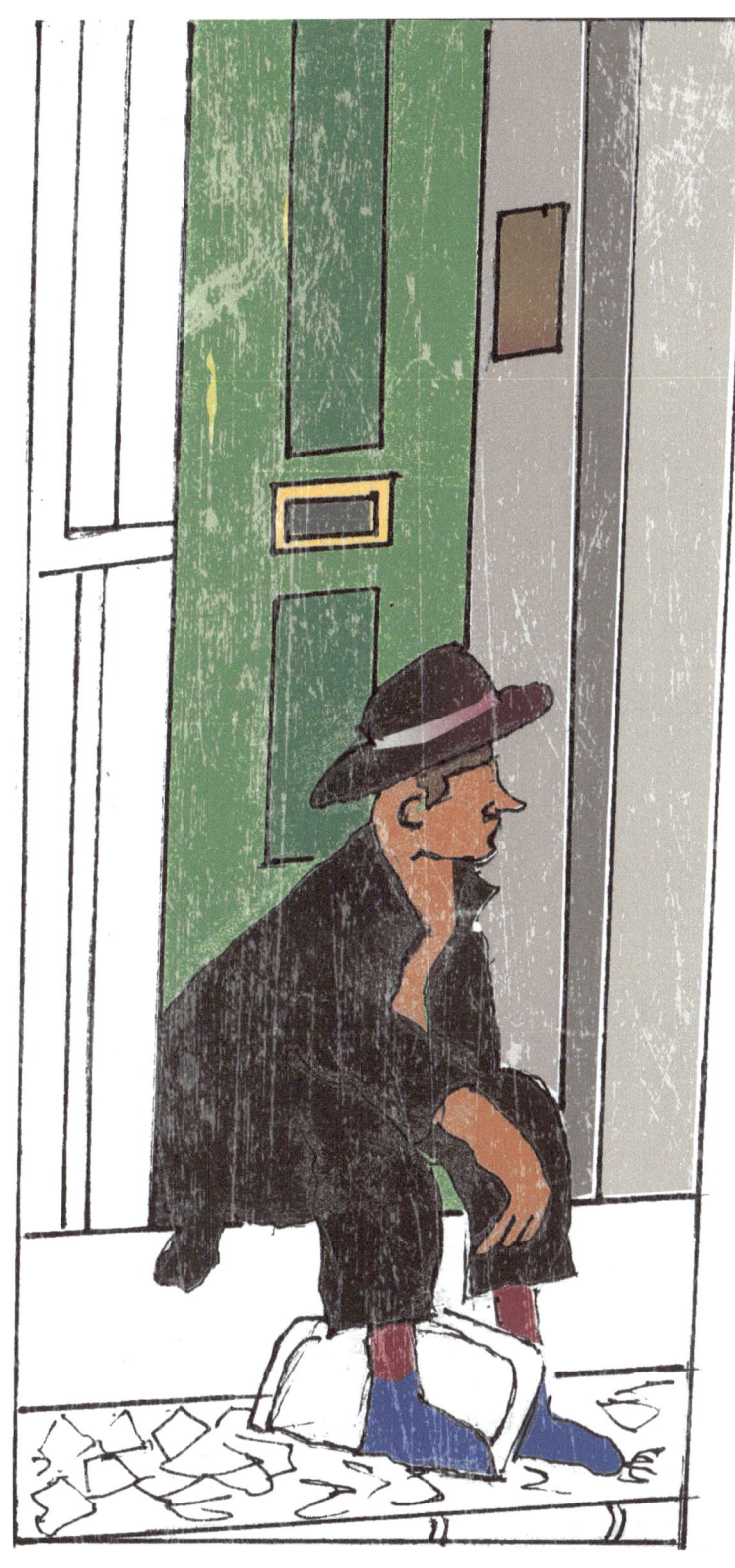

Paris Street # 2

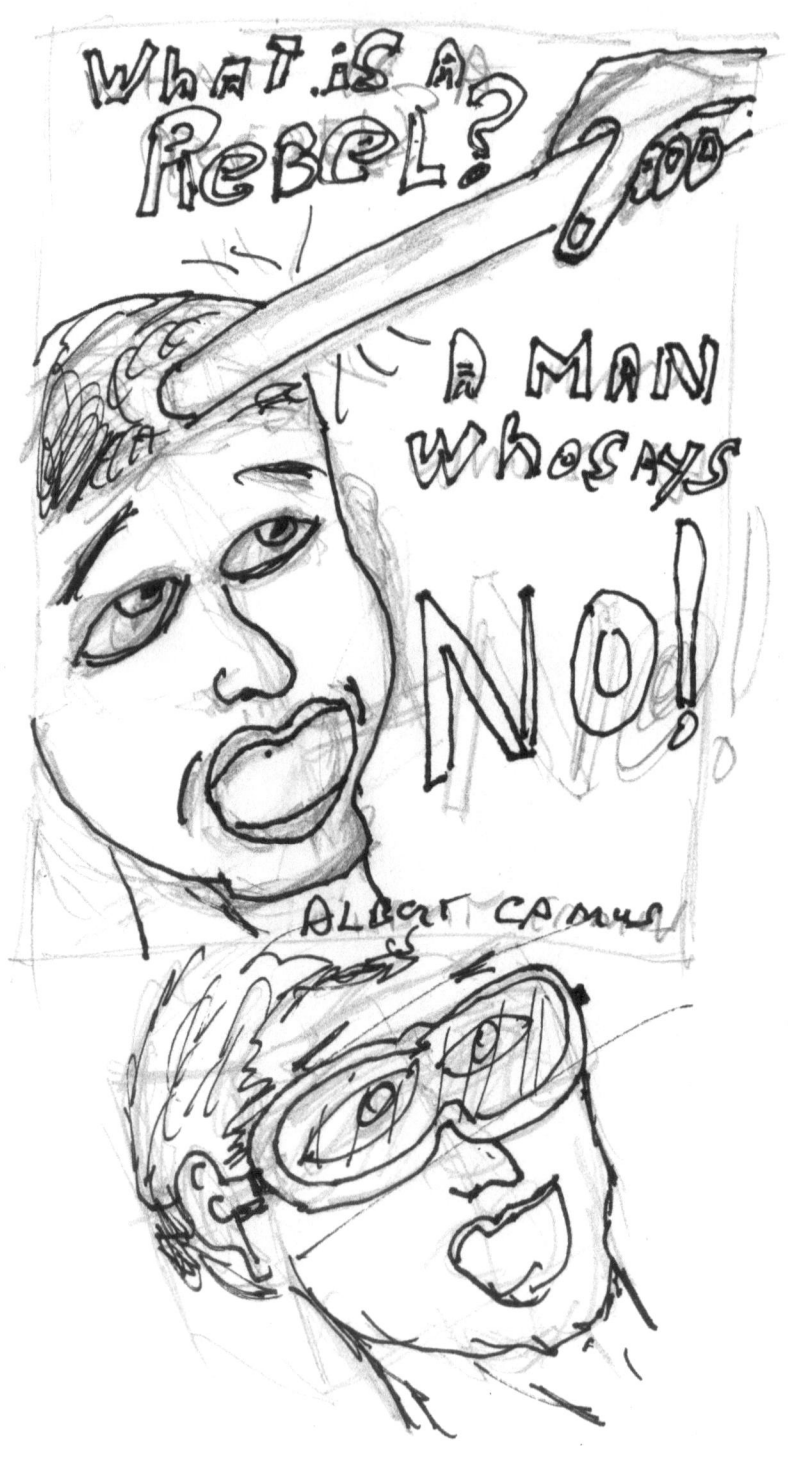

Albert Camus

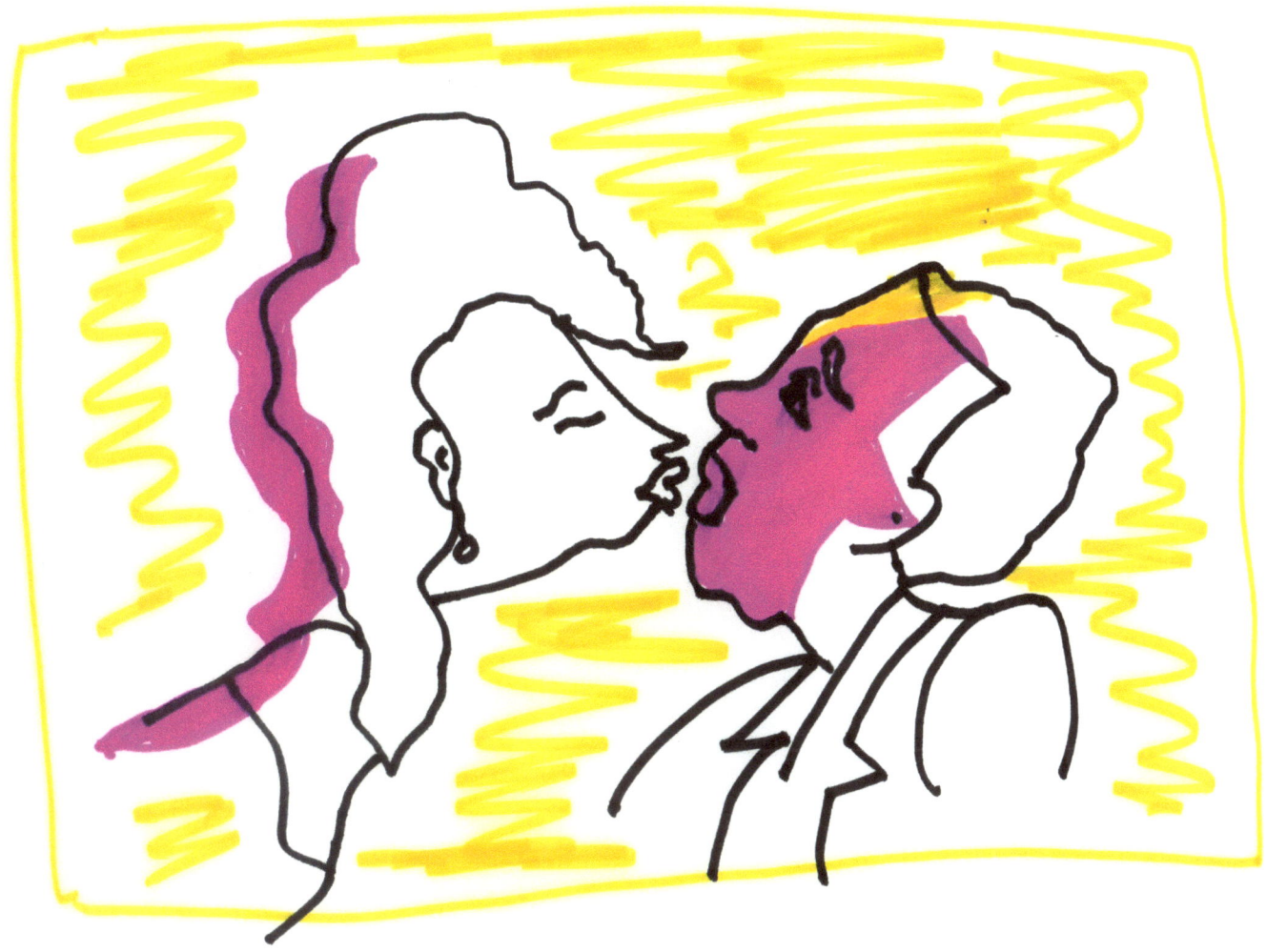

Cuba

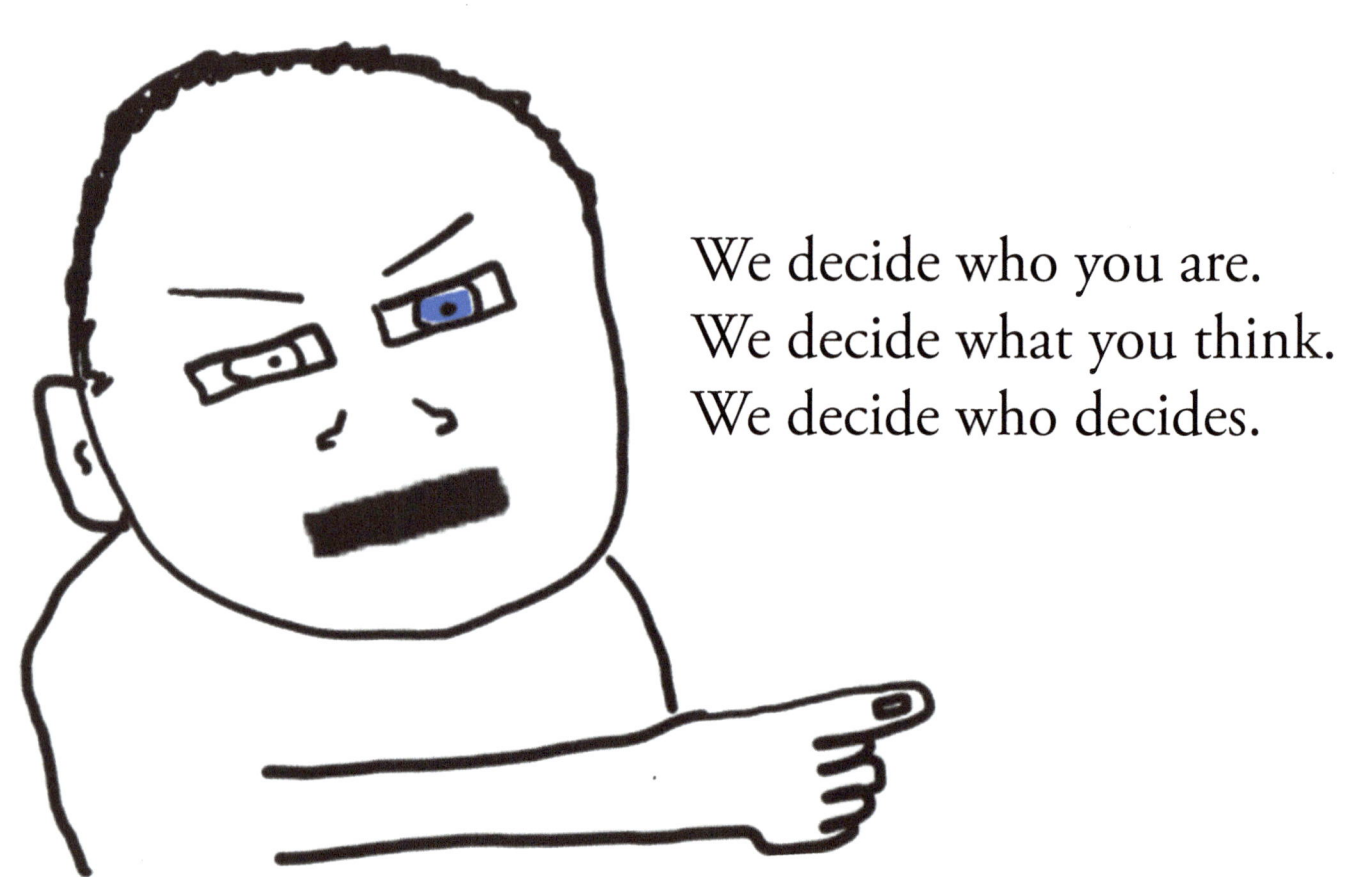

We decide who you are.
We decide what you think.
We decide who decides.

Isms

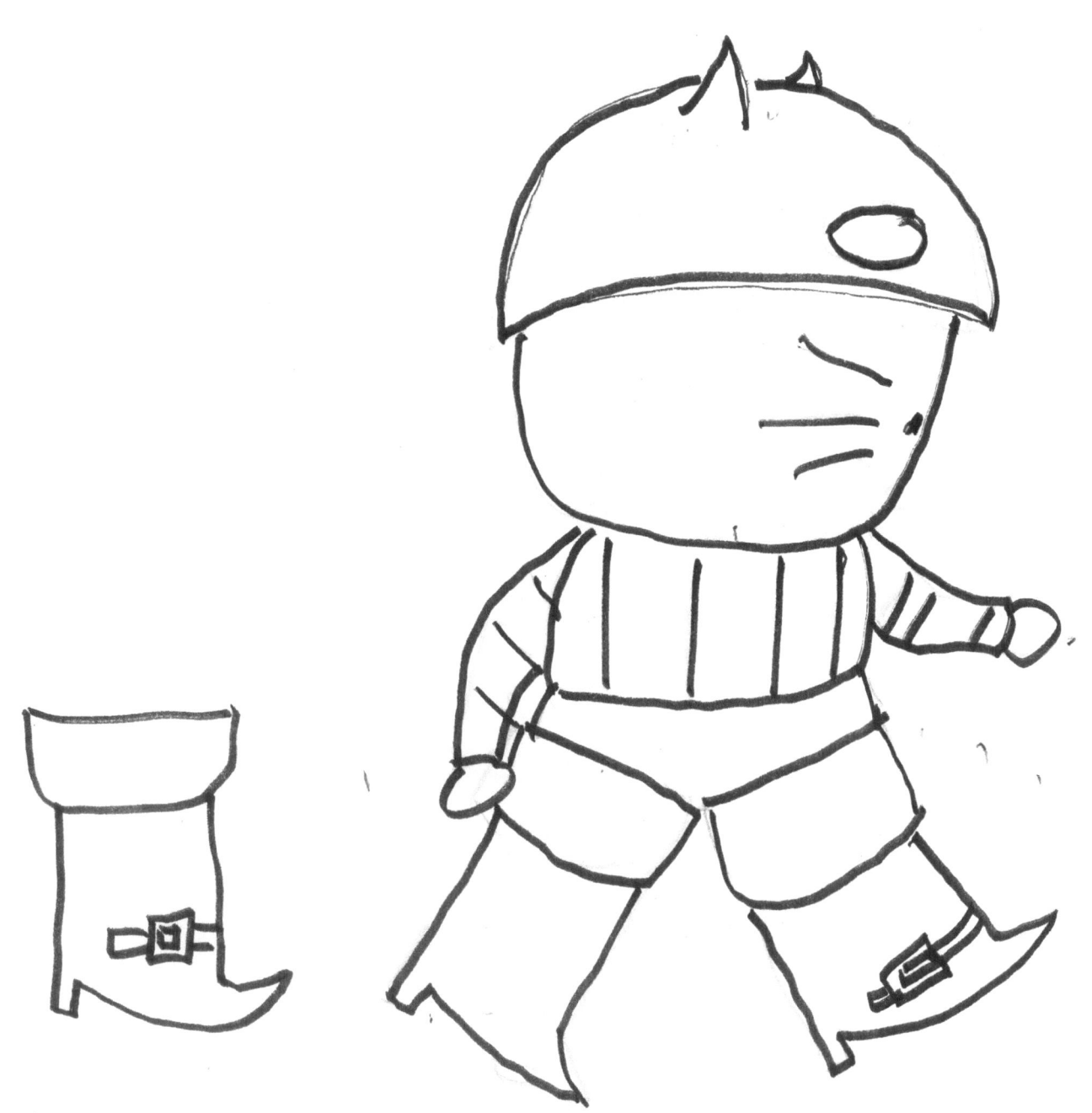

Cat Boot

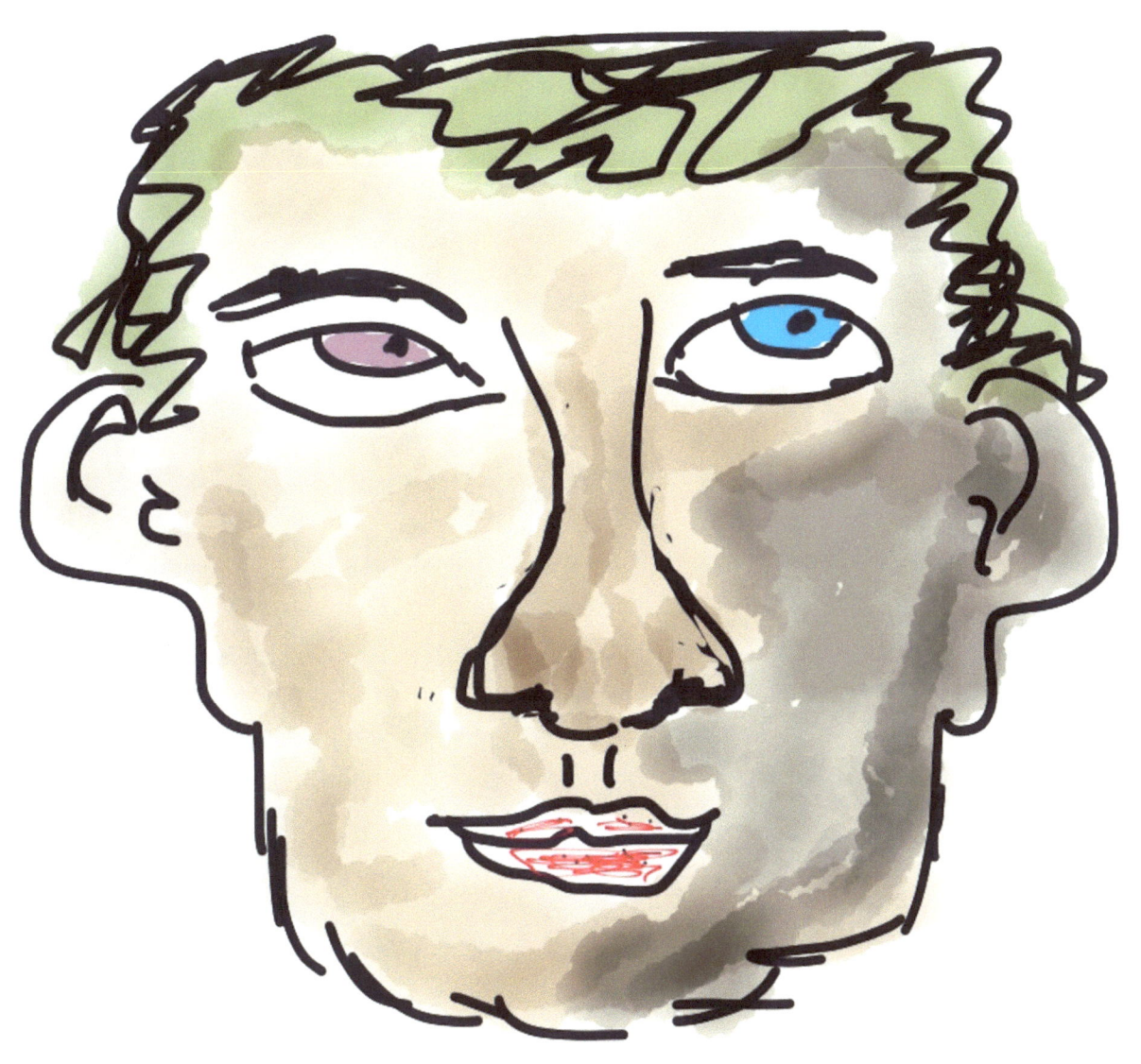

Man #7: Paper 53

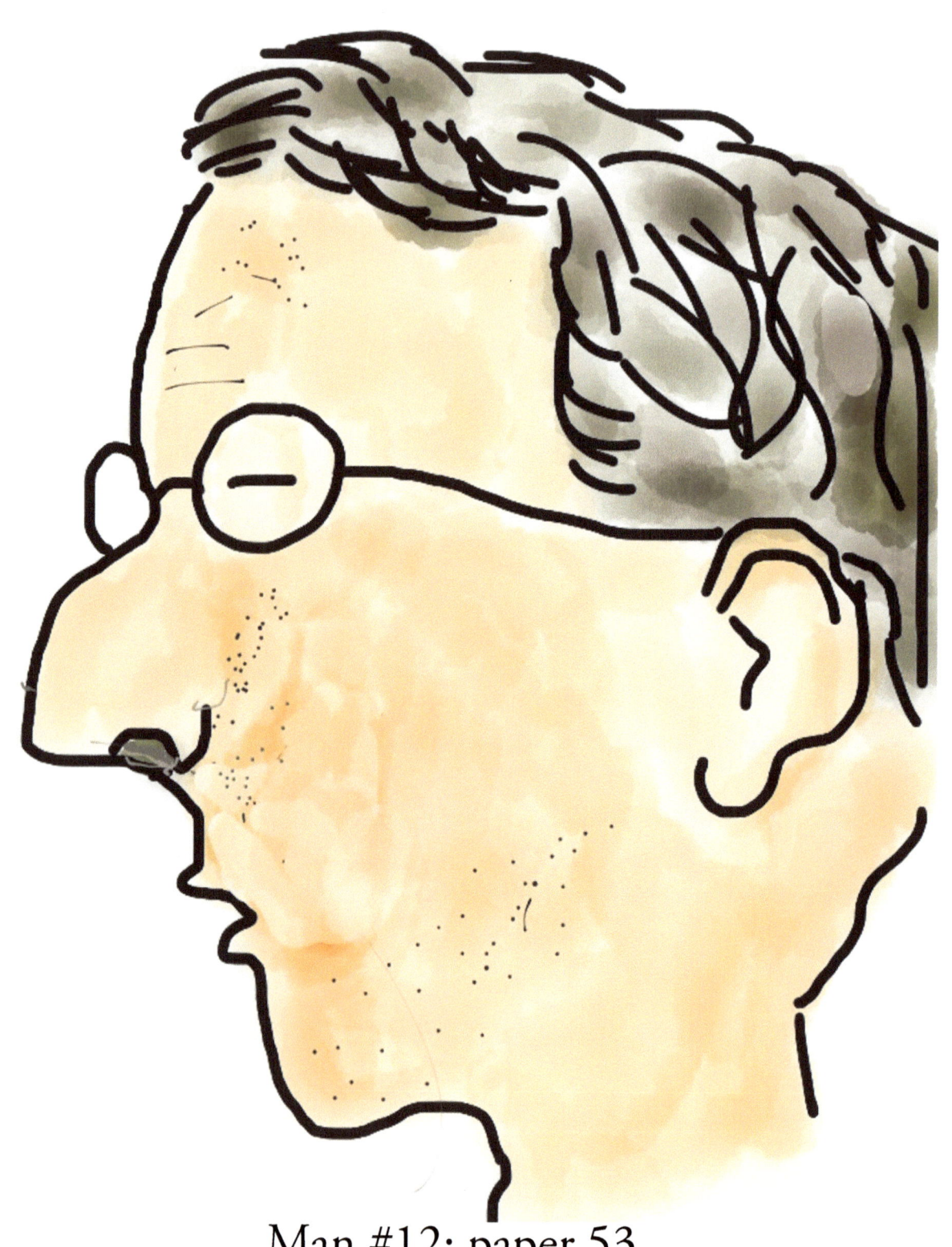

Man #12: paper 53

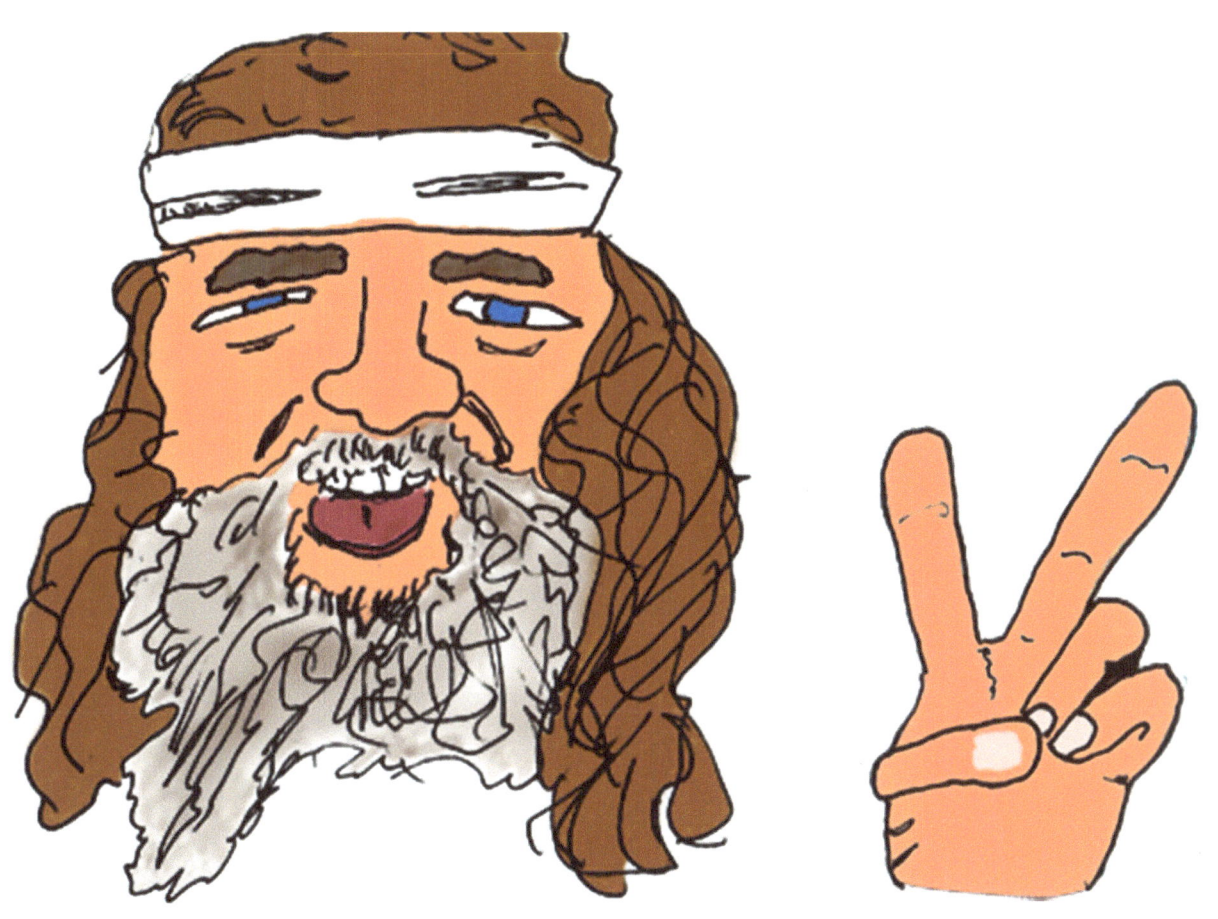

Hippie

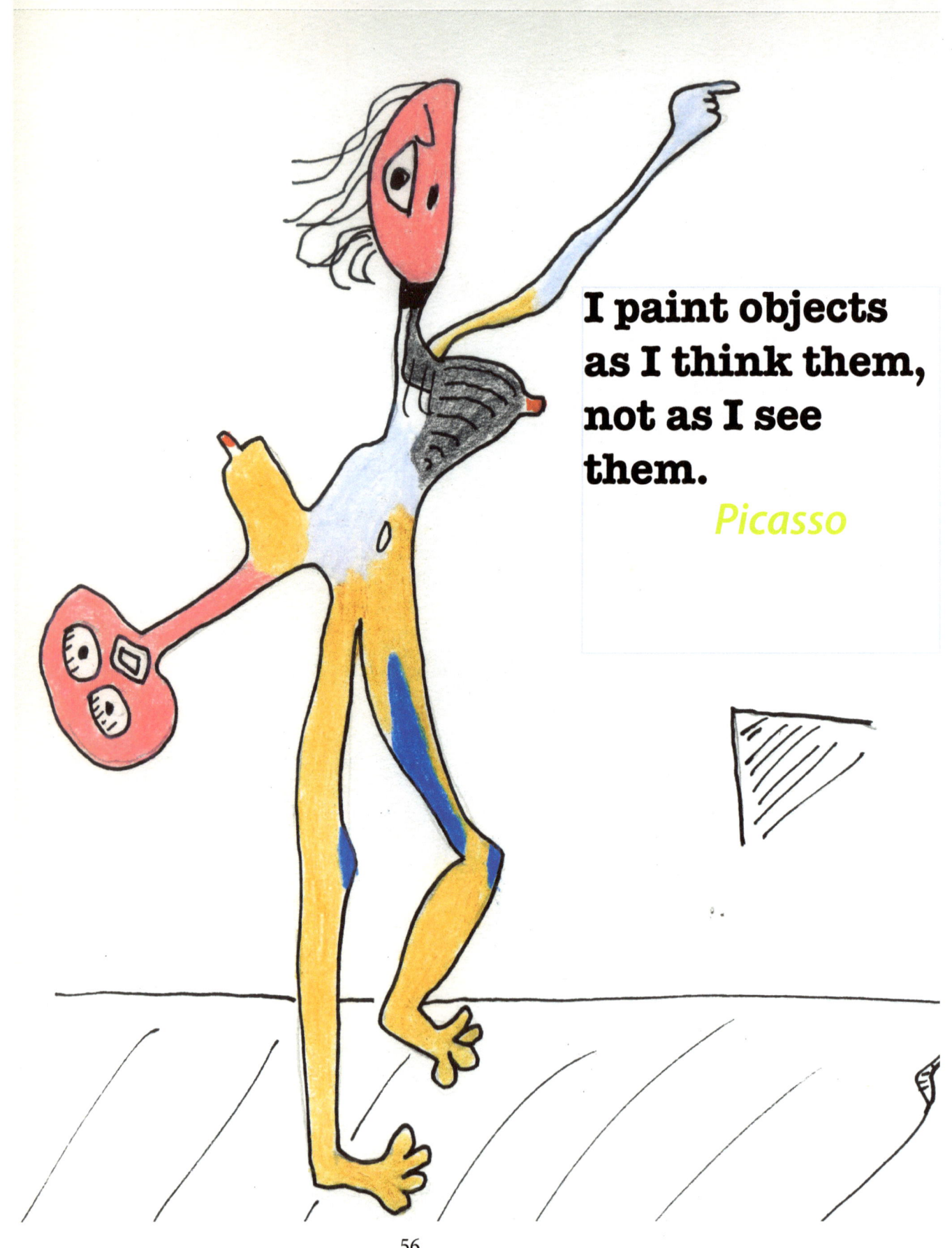

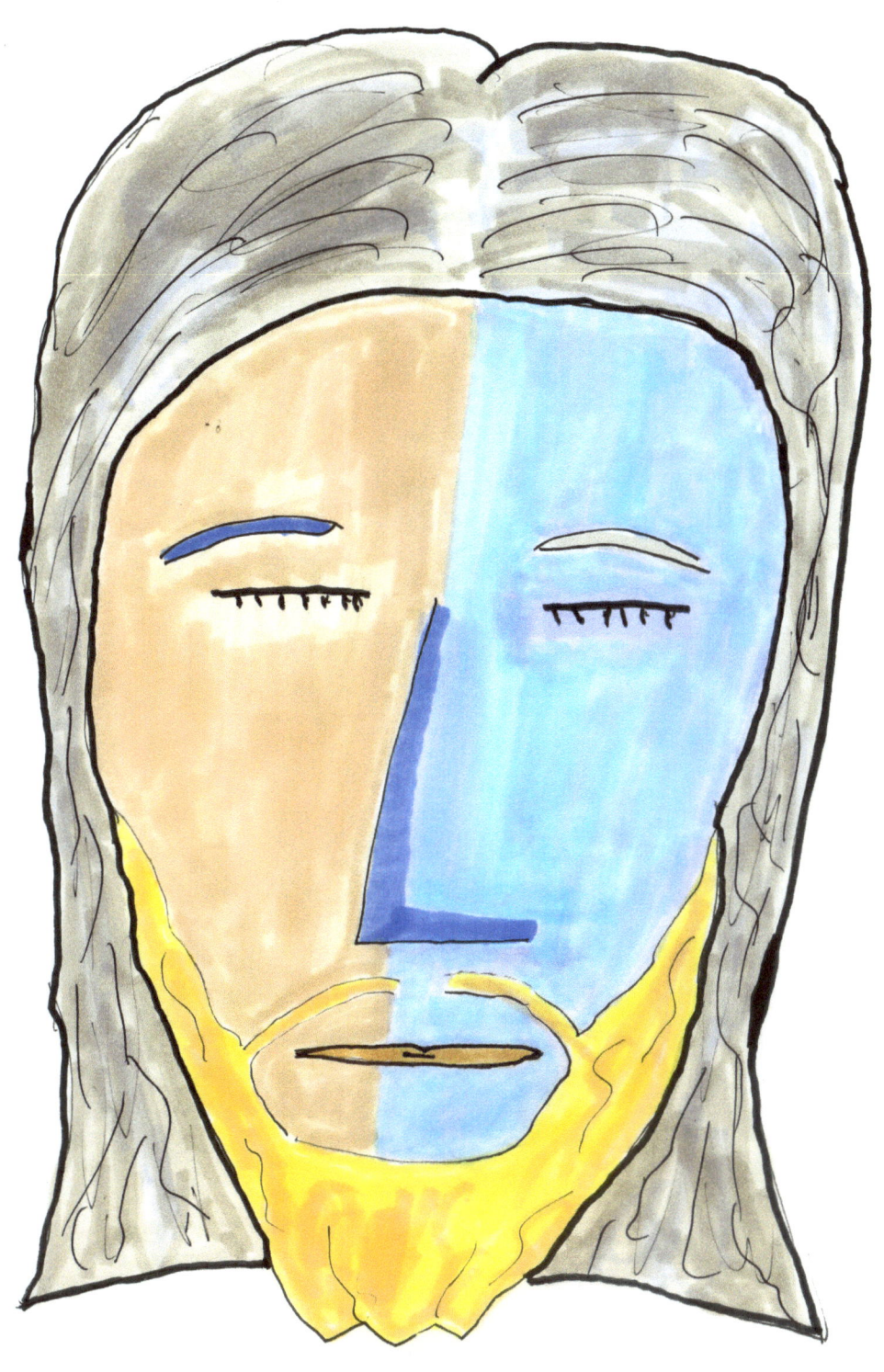

Kells Jesus

HE WHO LAUGHS
HAS NOT YET
HEARD THE
BAD NEWS!

BERTOLT BRECHT

Bertolt Brecht

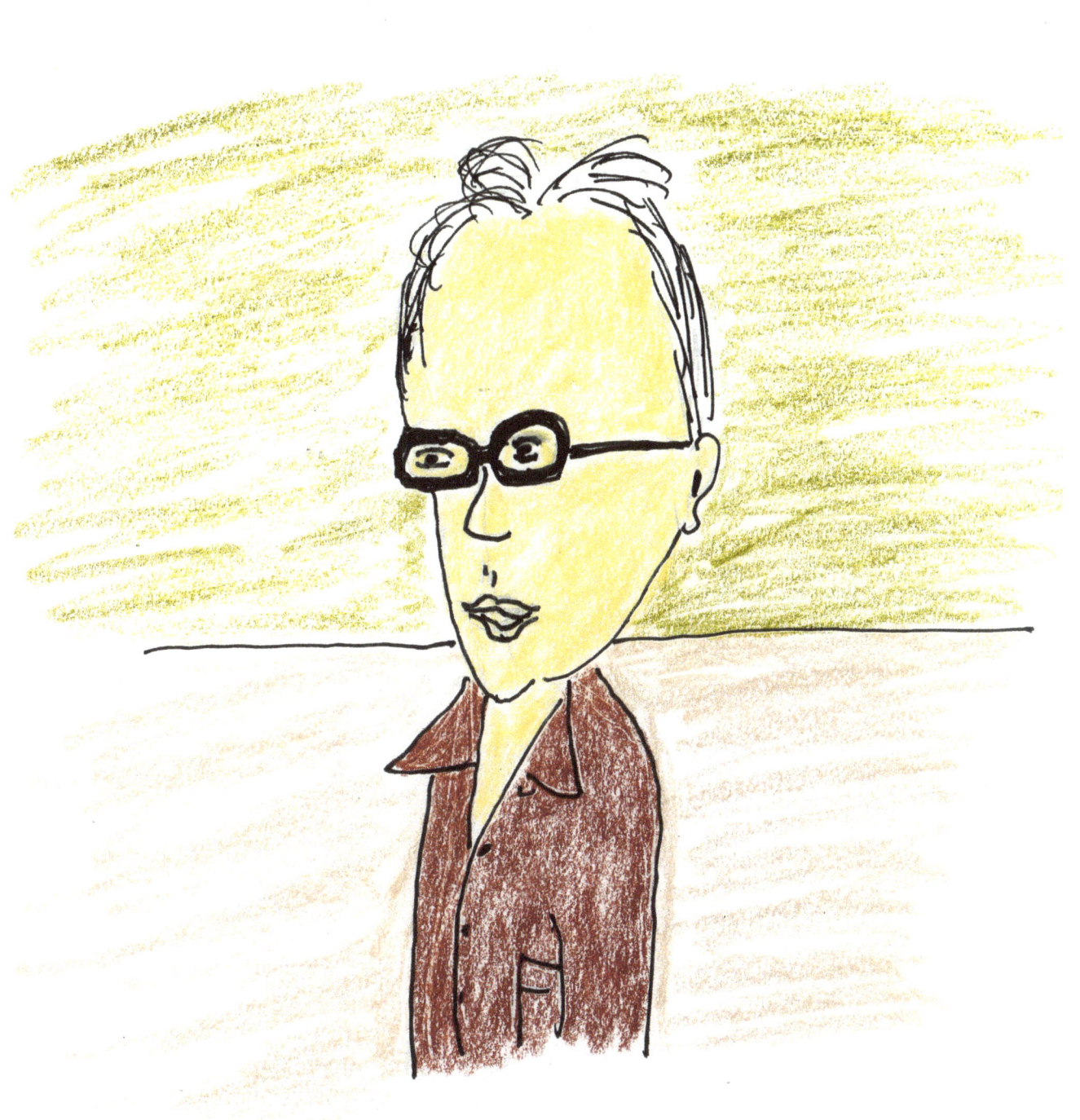

Studious

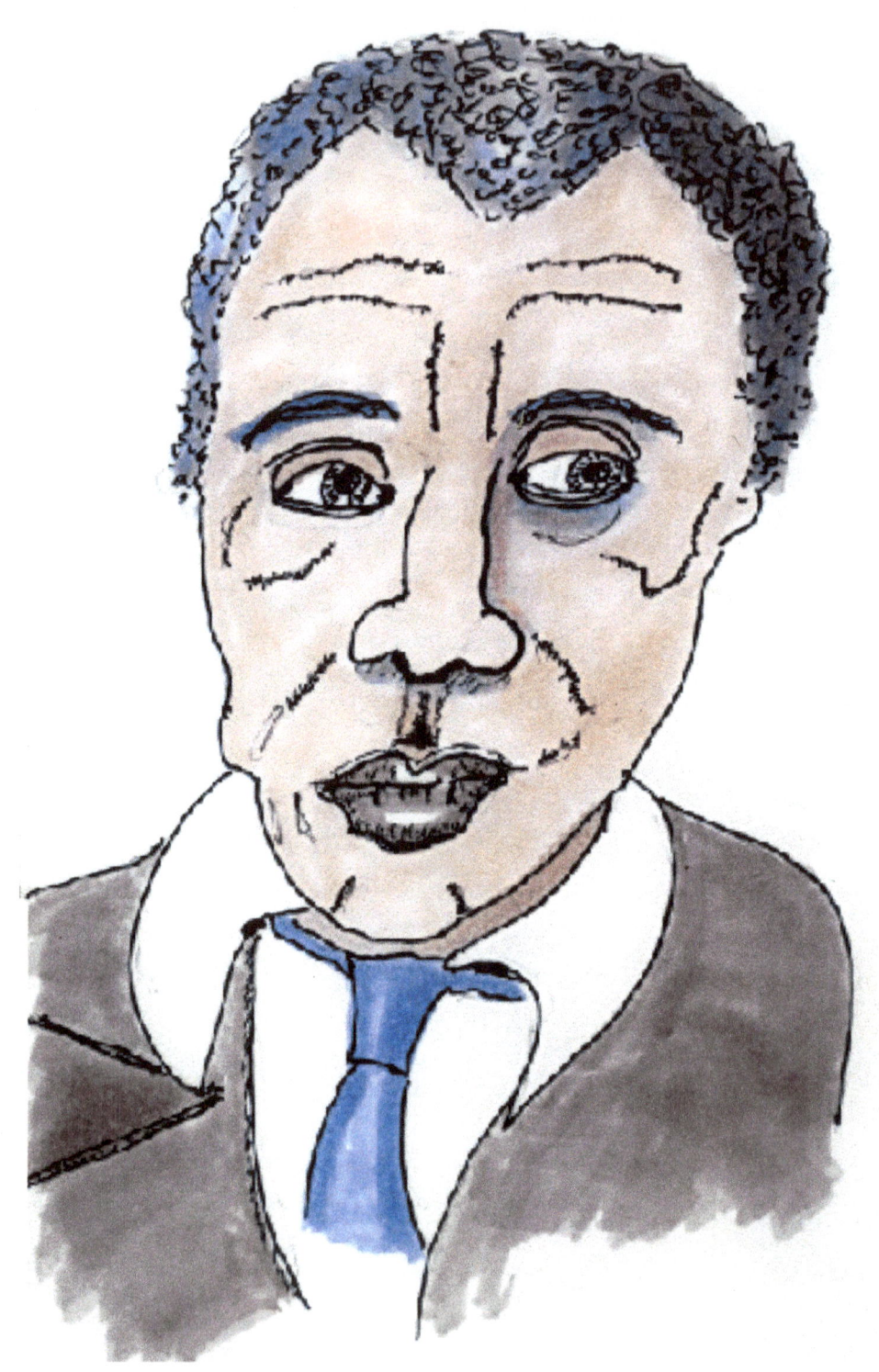

"Artists are here to disturb the peace."
James Baldwin: 1924-1987

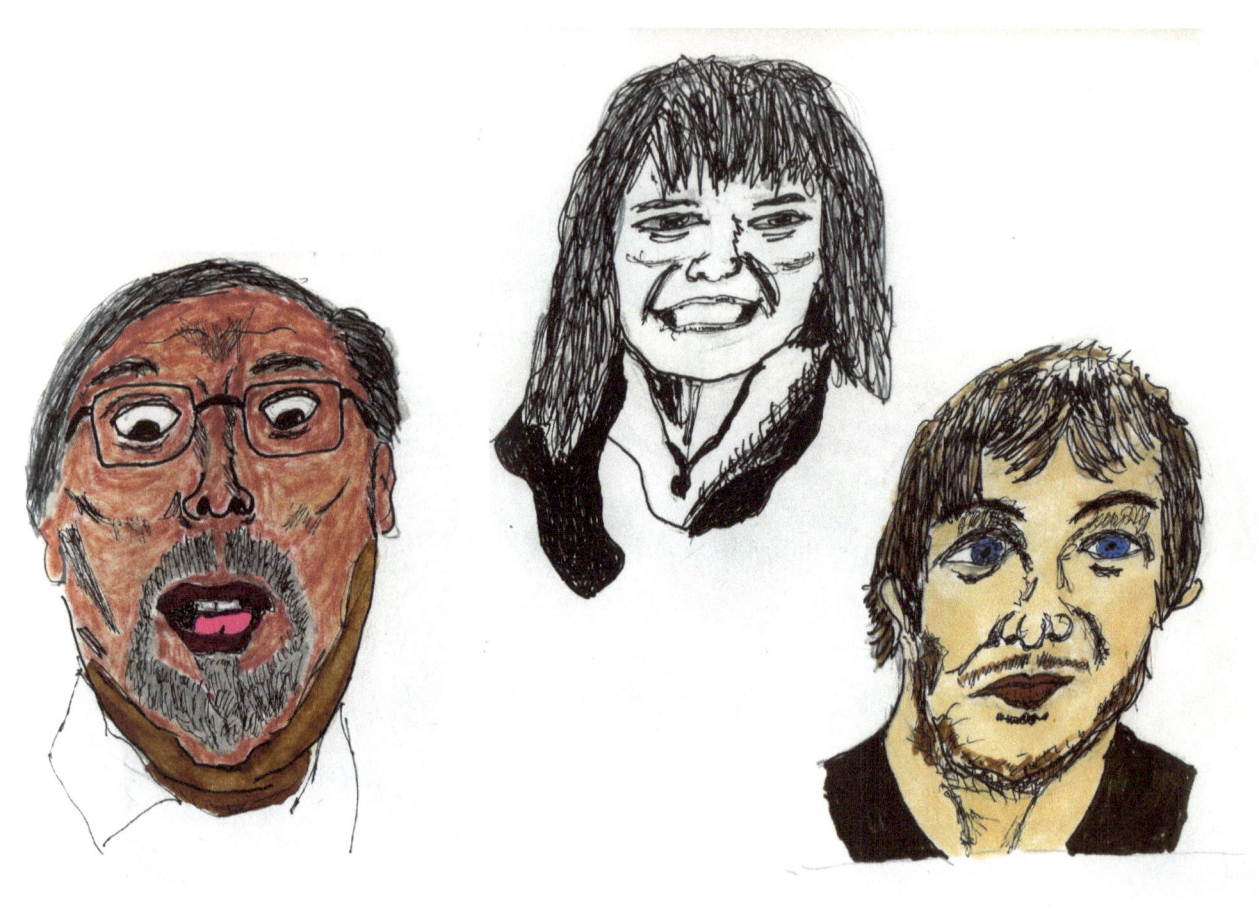

Teresa -A Rose Among The Thorns

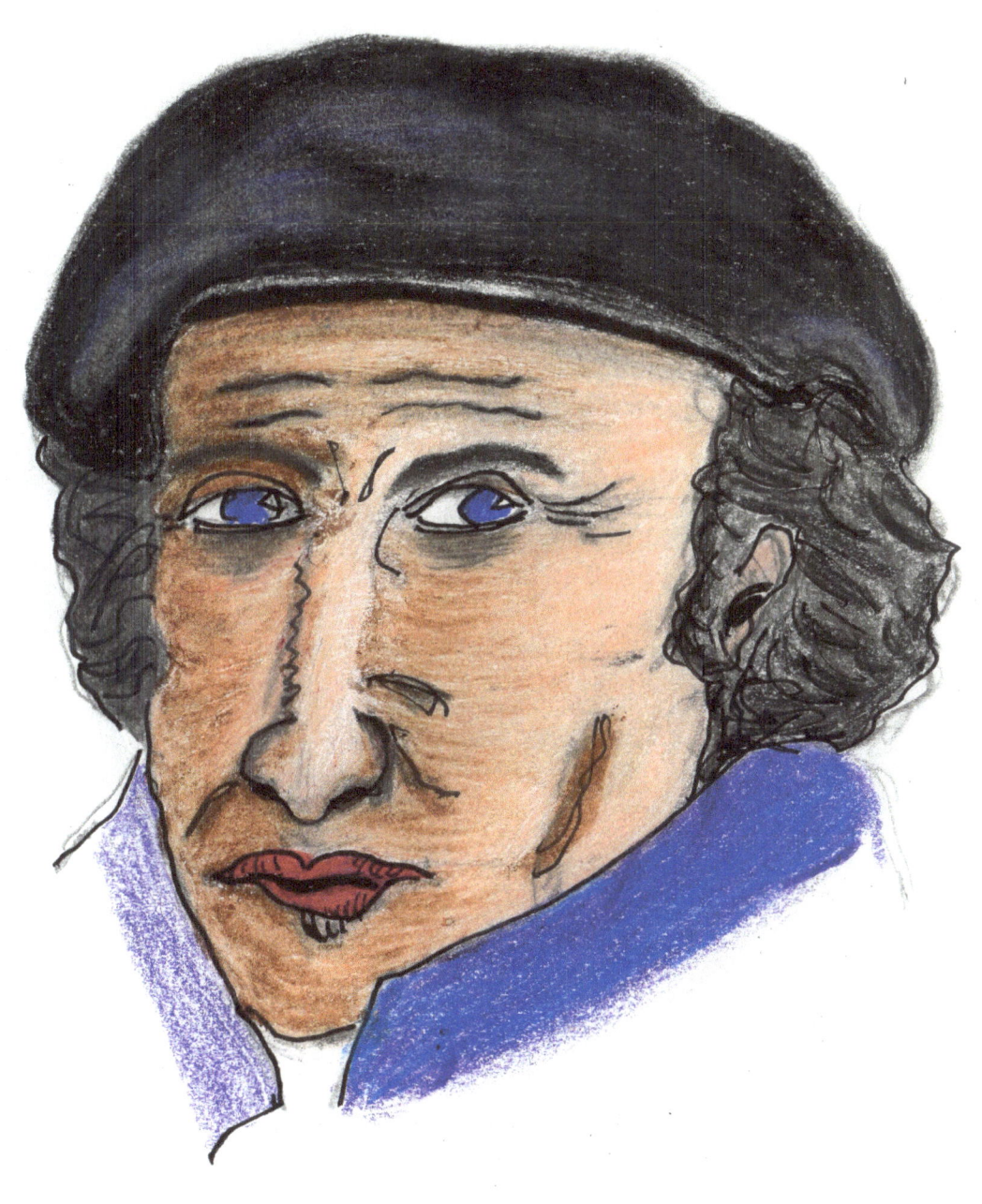

Rembrandt van Rijn

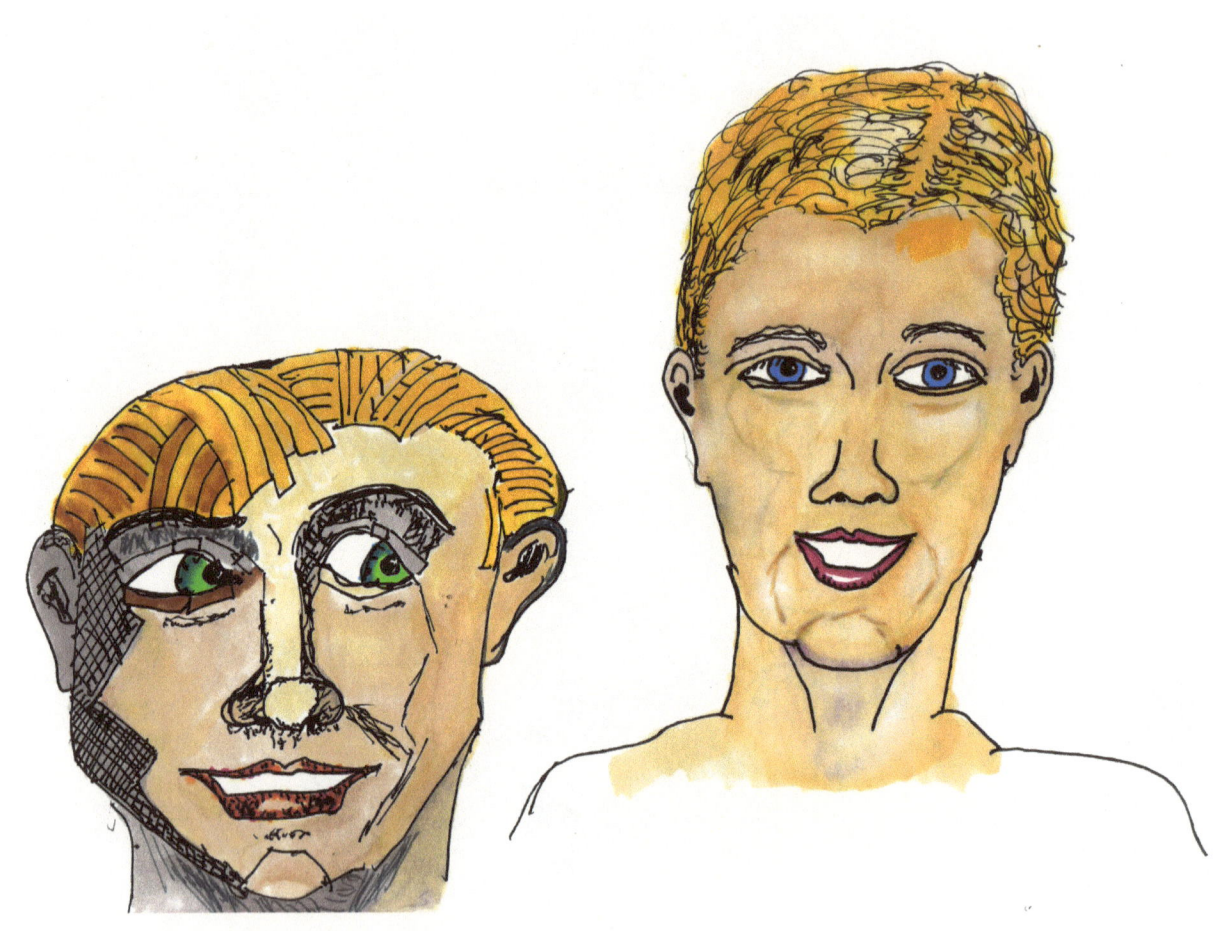

Good Look'in

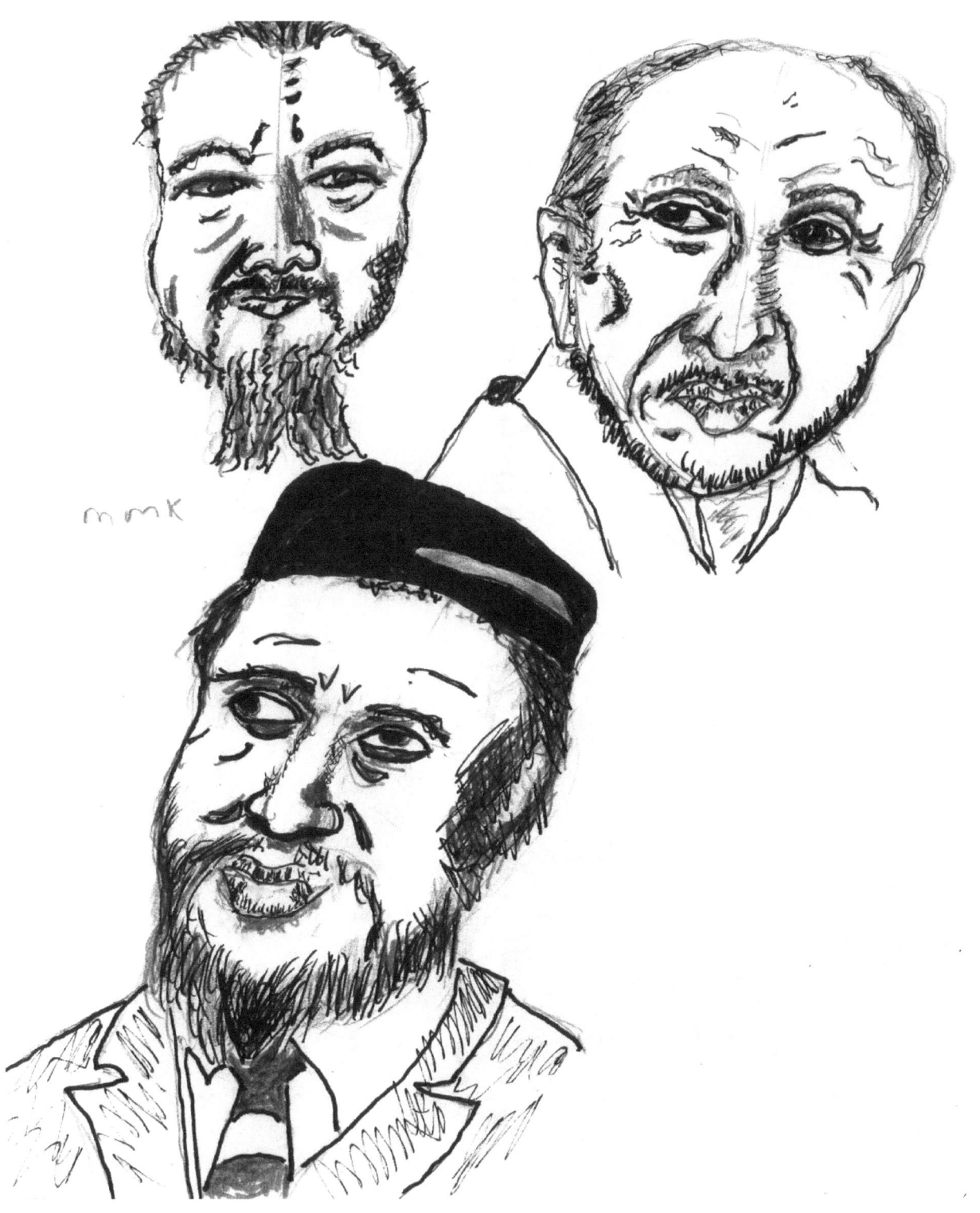

Monk, Ai Weiwei & Mustafa Abdul Jalil

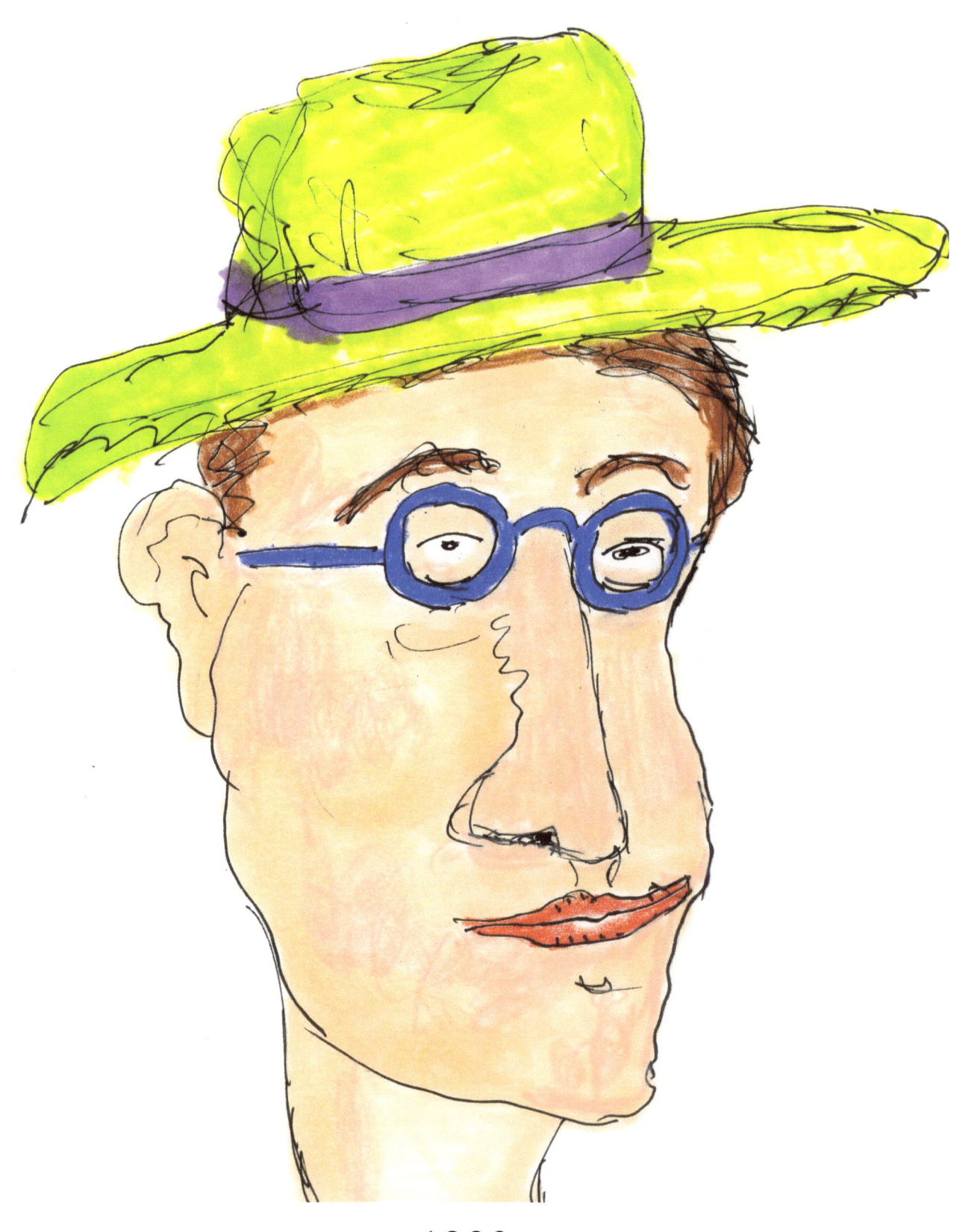

1930

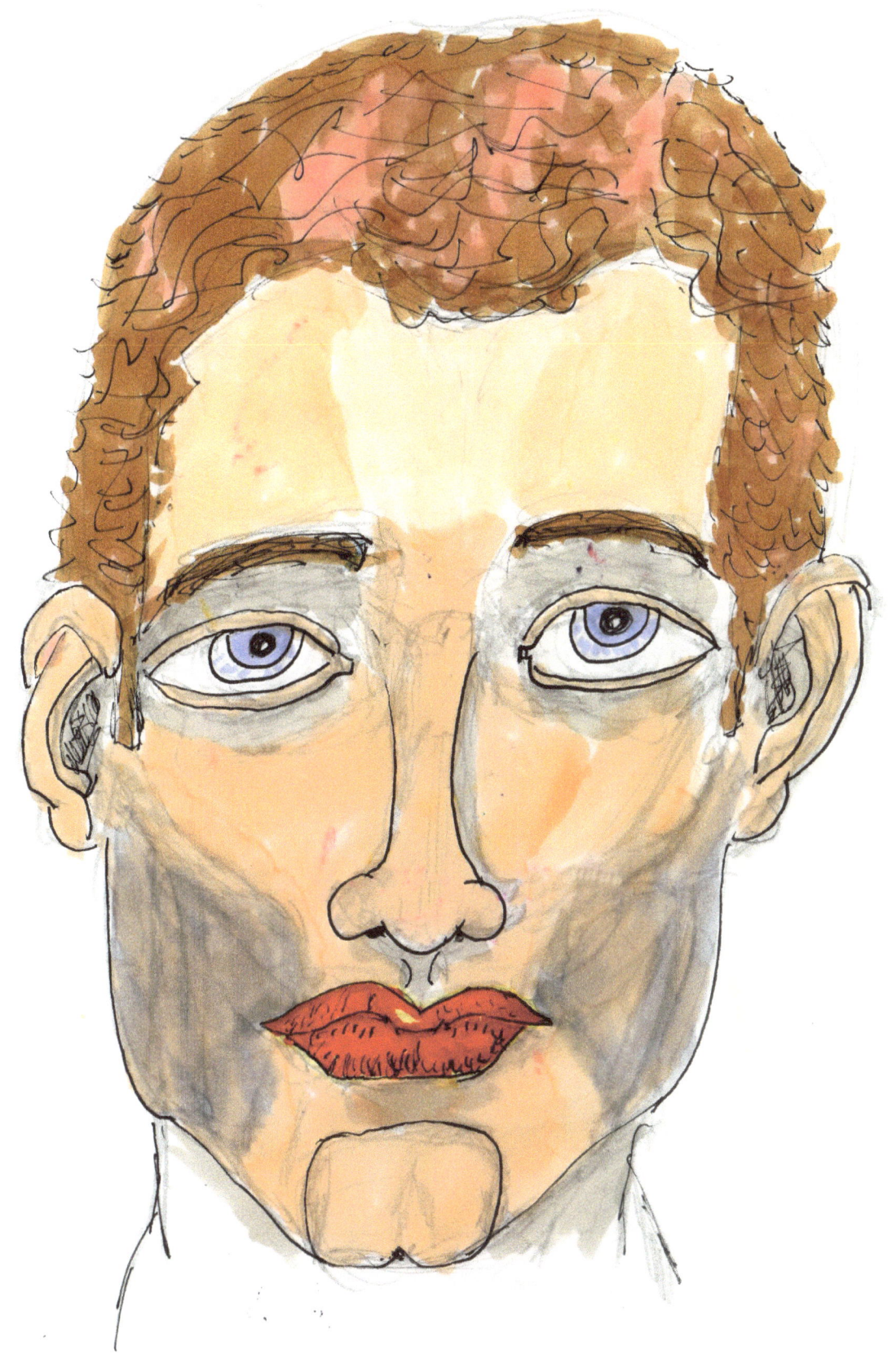

Man #11

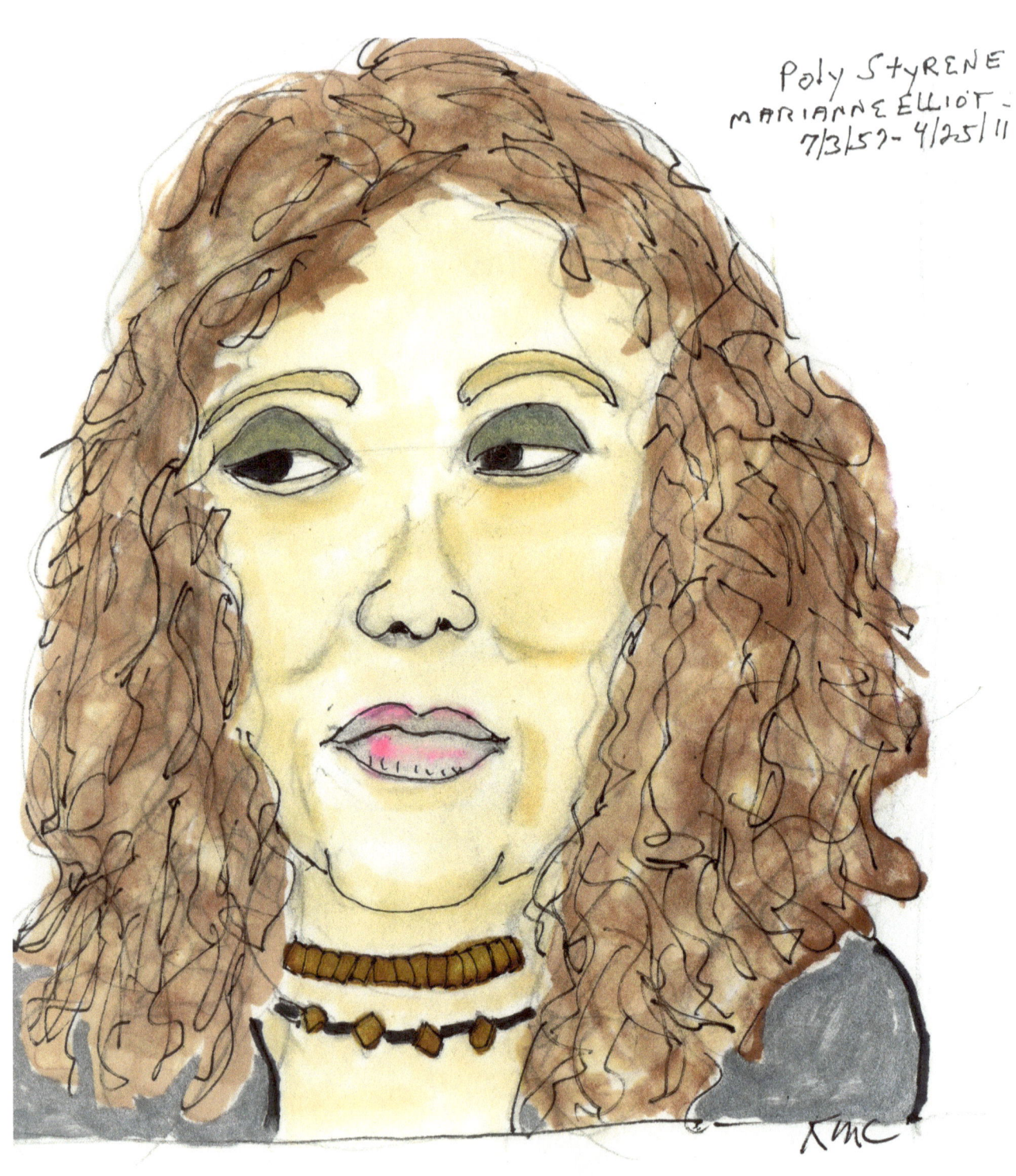

Poly Styrene